Paint Landscapes in Acrylic With Lee Hammond

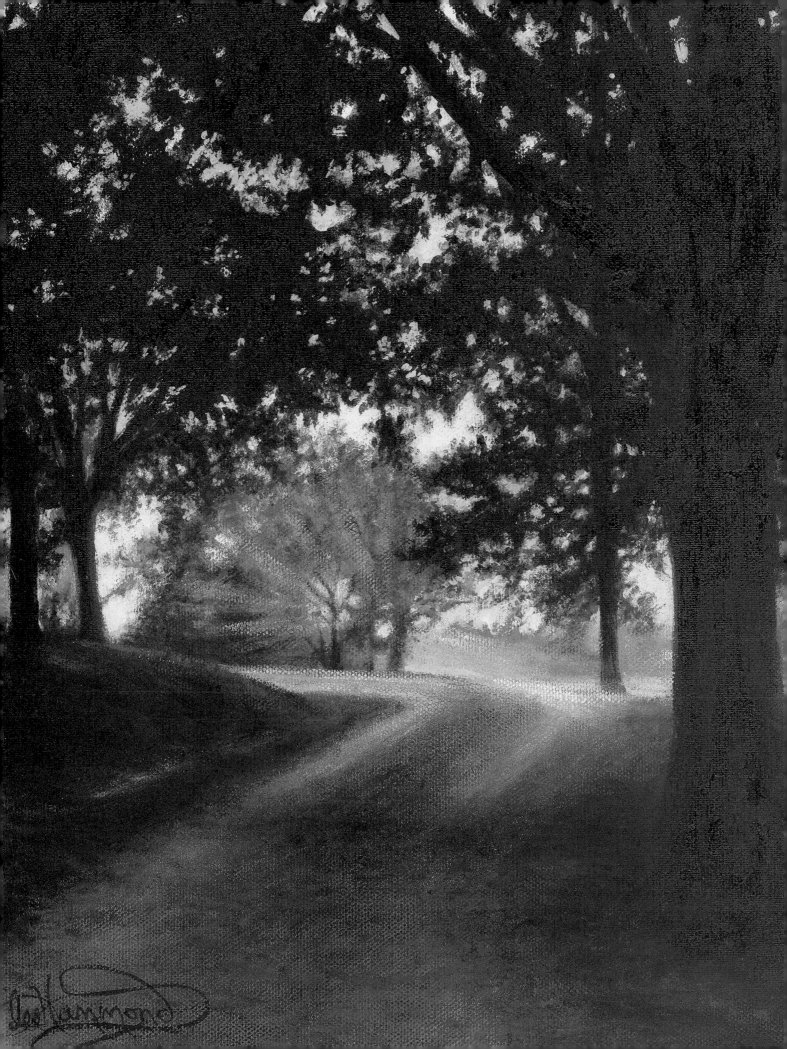

PAINT LANDSCAPES
IN ACRYLIC

With Lee Hammond

NORTH LIGHT BOOKS
CINCINNATI, OHIO
www.artistsnetwork.com

About the Author

A professional artist and instructor for more than thirty years, Lee Hammond has authored more than twenty North Light Books including *How to Draw Lifelike Portraits from Photographs*, *Lifelike Drawing With Lee Hammond* and *Paint Realistic Animals in Acrylic With Lee Hammond*. She conducts drawing and painting seminars, gives school lectures and mentors nationwide. A certified police composite artist on call for the Kansas City metro area, she has also worked with *America's Most Wanted*, been a contributing writer for *The Artist's Magazine* and was licensed with many of NASCAR's racing teams to produce art and prints.

Visit her website at www.leehammond.com.

Paint Landscapes in Acrylic With Lee Hammond. Copyright © 2009 by Lee Hammond. Manufactured in the U.S.A. All rights reserved. No part of this book may be reproduced in any form or by any electronic or mechanical means including information storage and retrieval systems without permission in writing from the publisher, except by a reviewer who may quote brief passages in a review. Published by North Light Books, an imprint of F+W Media, Inc., 4700 East Galbraith Road, Cincinnati, Ohio, 45236. (800) 289-0963. First Edition.

Other fine North Light Books are available from your favorite bookstore, art supply store or online supplier. Visit our website at www.fwmedia.com.

20 19 18 13 12 11

DISTRIBUTED IN CANADA BY FRASER DIRECT
100 Armstrong Avenue
Georgetown, ON, Canada L7G 5S4
Tel: (905) 877-4411

DISTRIBUTED IN THE U.K. AND EUROPE BY DAVID & CHARLES
Brunel House, Newton Abbot, Devon, TQ12 4PU, England
Tel: (+44) 1626 323200, Fax: (+44) 1626 323319
E-mail: postmaster@davidandcharles.co.uk

DISTRIBUTED IN AUSTRALIA BY CAPRICORN LINK
P.O. Box 704, S. Windsor NSW, 2756 Australia
Tel: (02) 4577-3555

Library of Congress Cataloging in Publication Data
Hammond, Lee, 1957-
 Paint landscapes in acrylic with Lee Hammond / Lee Hammond. -- 1st ed.
 p. cm.
 Includes index.
 ISBN 978-1-60061-309-8 (pbk. : alk. paper)
 1. Landscape painting--Technique. 2. Acrylic painting--Technique. I. Title.
 ND1342.H36 2009
 751.4'26--dc22 2009026161
Edited by Mona Michael
Designed by Guy Kelly
Production coordinated by Matt Wagner

Acknowledgments

North Light Books has given me opportunities that I never in my wildest dreams imagined to be possible. Thank you from the bottom of my heart to each and every one of you (you know who you are!) for keeping me so busy throughout these years and for supporting me so completely with my career. *Thank you* just isn't enough for all you have done for me.

I have definitely worked with some of the best people in the industry with North Light Books, and I am fortunate to have them not only as my team but also as my dear friends. I feel lucky beyond words! Here's to many, many more years of making our dreams come true together!

Metric Conversion Chart		
To convert	to	multiply by
Inches	Centimeters	2.54
Centimeters	Inches	0.4
Feet	Centimeters	30.5
Centimeters	Feet	0.03
Yards	Meters	0.9
Meters	Yards	1.1

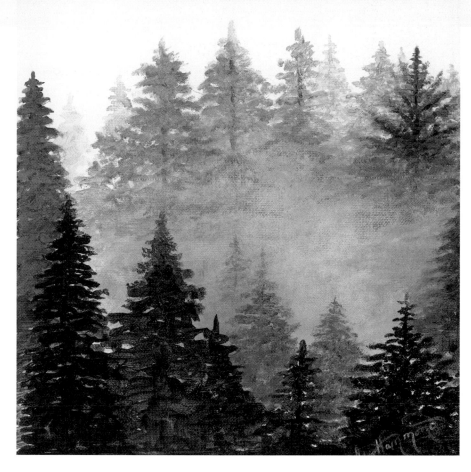

MISTY VERMONT PINES
11" × 15" (28cm × 38cm)

Colors Used: Cadmium Yellow Medium, Ivory Black, Prussian Blue and Titanium White

Foreword

Learning something new is never easy. Learning to paint is not either. However, the rewards for hard work and much practice can produce wonderful results, making the learning experience much more enjoyable and worthwhile. This is the first time I have not included reference photos in my book. I have a number of reasons for leaving them out this time. When painting, I find that some students get too dependent on the photo, trying to become a human copy machine. This is very inhibiting. Painting should be freer than that. Also, much of what is in a photo is left out when painting landscapes. I have found in the past, students can get very caught up in the differences between the finished painting and the photo, and become very confused. The photo is just a reference. By eliminating photos, all the focus can go to the painting process. Also, by not devoting precious space to photos, I can offer more valuable step-by-step projects to help you learn. I have written this book with the beginner in mind, keeping the steps simple and the projects unique. Don't be afraid to experiment and make mistakes. Acrylic is so forgiving. If you don't like what you have done, let it dry, and in a few minutes, simply cover it up! Don't allow the Awkward Stage to scare you either, for it is an inevitable and necessary step. The Awkward Stage is the crossroads that will take you in a wonderful direction. Just relax, for there is really no right or wrong in painting. Think of it more as fun and experimentation. I will guide you through it, helping you to produce some beautiful paintings. Allow me to be your personal artistic mentor.

Dedication

This book is dedicated to all of the people who, like me, find art to be an irresistible and insatiable calling. What lucky people we are to have this talent, for I believe we see and feel things differently than most. For anyone else who has ever felt that their art has literally saved them, this one is for you!

Contents

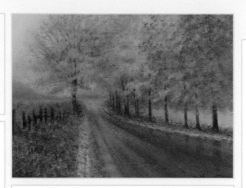

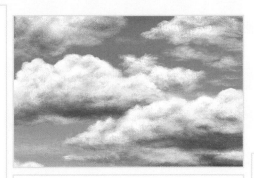
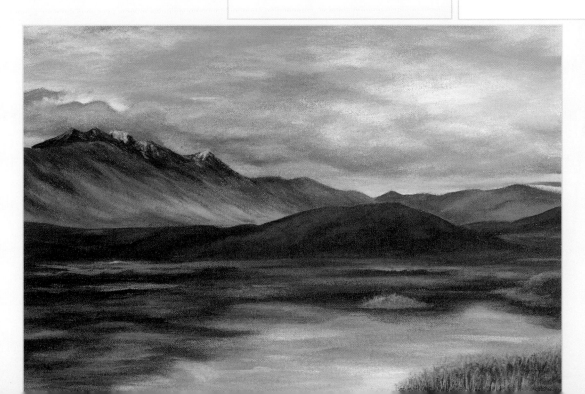

Introduction

I've wanted to write this book for a long time. I love landscapes and sky scenes, finding their colors truly magnificent. I never tire of looking at the sky, for it always provides a never-ending display of shapes and colors. There was a time when I thought my entire career was going to be about skies and landscapes. I just couldn't get enough of them, and that is what I taught in my art classes. Each class was all about painting landscapes, and I wasn't alone in my love of them. My classes were always full.

As time went on though, I felt the need to expand, not only for me, but also for my students. So I forced myself to become more diverse in my artwork. I branched out into portraits, animals, flowers and various mediums. But deep inside, I always remembered my love of landscapes and was thrilled when North Light gave me the opportunity to write this book and indulge myself once more in painting their beauty.

I wanted this book to be different though. Many of the other landscape books I looked at seemed the same to me. I wanted this one to stand out, to be more exciting, yet obtainable. Nothing is worse than looking at an art book and feeling that you could never do it.

I've chosen projects that have interesting aspects to them, through either the use of color or unusual compositions. I've kept the stages fairly simple, keeping to a three-step process. I've also kept the palette simple, using only eight colors and mixing all of the others. It doesn't have to be any harder than it needs to be. As with anything, it will require practice and experimentation. But acrylic is awesome for doing that. I don't know of any other medium that can be reworked and altered as easily.

Follow along with me and have fun. Acrylic will soon become one of your favorite mediums, and then the sky will be the limit!

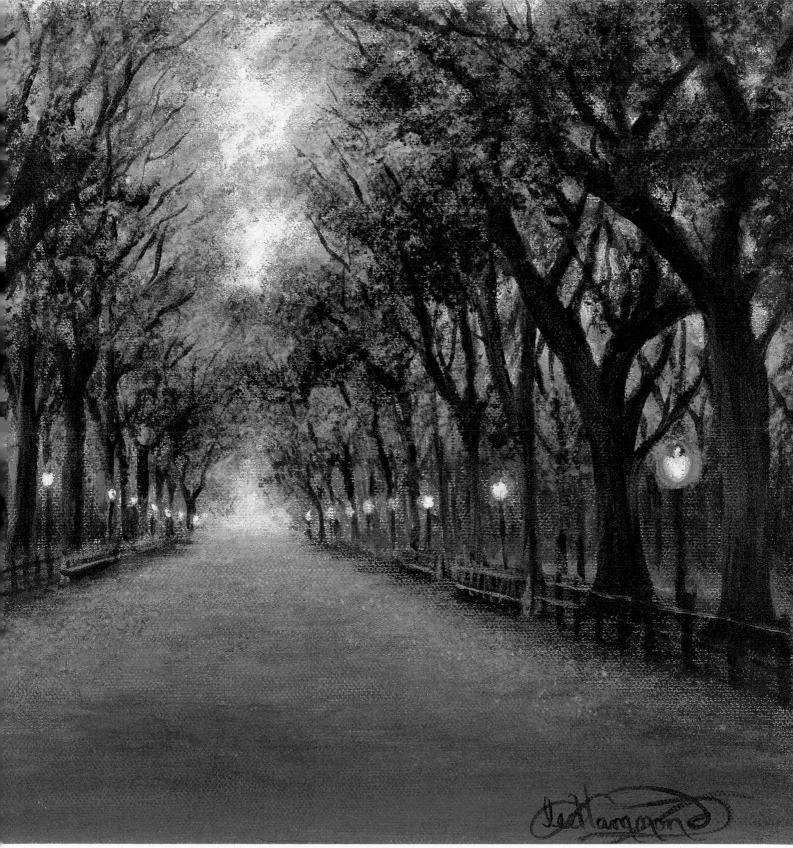

This is the type of art possible with acrylic paint. While it may seem daunting at this point, please give this book, as well as yourself, a chance to create magic!

CENTRAL PARK
9" × 12" (23cm × 30cm)

Colors Used: Alizarin Crimson, Burnt Umber, Cadmium Red Light, Cadmium Yellow Medium, Dioxazine Purple, Ivory Black, Prussian Blue and Titanium White

1
Getting Started

I use a very small number of colors on my palette and only a few different brushes. Keeping it simple makes me feel more relaxed in my work area.

A tackle box is a great place to keep your painting supplies. It's easy to carry with you when you want to paint on location, and it acts like a storage unit when you're not painting. Have fun creating your own custom acrylic painting kit! Everything you'll need to get started is listed on this page.

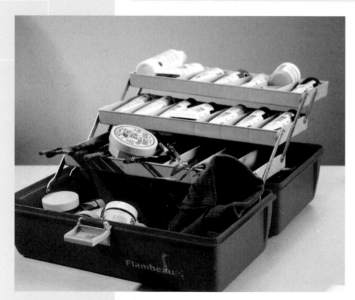

Paints, Tools and Supplies
A simple set of tools and a limited palette of colors are all you need to start painting in acrylics. A tackle box makes a great storage unit.

Start-Up Kit

Below is a list of essentials you should have on hand to get you started on the painting projects in this book. Happy painting!

Paints: Alizarin Crimson, Burnt Umber, Cadmium Red Light, Cadmium Yellow Medium, Dioxazine Purple, Ivory Black, Prussian Blue, Titanium White.

Surfaces: Prestretched canvases, canvas panels and/or canvas sheets.

Brushes: ¾-inch (19mm) filbert, no. 3 filbert, no. 4 filbert, no. 6 filbert, no. 8 filbert, no. 2 liner, no. 1 liner, no. 2/0 liner, no. 2/0 round, no. 2 round, no. 4 round, no. 6 round, no. 6 flat, no. 4 flat, hake.

Palette: Plastic, with a lid (or improvise your own—see page 17).

Other Materials: Cloth rags, wet wipes, cans or jars, spray bottle of water, palette knife, masking or drafting tape, mechanical pencil with 2B lead, straightedge, kneaded eraser.

What Is Acrylic Paint?

Acrylic paints are made of dry pigment in a liquid polymer binder, which is a form of acrylic plastic. Acrylics are water-based, so they require no paint thinners as oil paints do, though they can be diluted with water while painting.

Acrylic paint dries quickly to a waterproof finish. Because of its plastic, waterproof quality, it can be used on a variety of surfaces. It is a favorite for painting on windows, outdoor signs, walls and fabric. It is permanent, so items painted with it are washable.

Varieties of Acrylic Paint

Many varieties of acrylic paints are available. Your choice depends partly on the project you're planning to do. There are acrylics formulated for folk art, fine art, even for painting on fabric, walls or signs.

For the projects in this book, look for paints labeled "high-viscosity" or "professional grade." Other kinds of acrylic paint will be too thin, with a pigment concentration too low for satisfactory results.

Student-grade paints and those in squeeze bottles generally have a lower concentration of pigment. The pigment is still high quality; there is just a little less of it. Many student grades are so good that professionals use them as well. They are very fluid, easy to work with and easy to mix.

Professional-grade paints have a higher concentration of pigment. They are usually a bit thicker than student-grade paints, and their colors may seem more deep and vivid. Professional grades are found in tubes or jars.

You will find paints in tubes, jars and squeeze bottles. I prefer using paint from a jar rather than from a tube or bottle. Acrylic paint dries quickly, so if I have some uncontaminated color left over on my palette, I return it to the jar to avoid wasting it. This is not possible with paint from a tube or bottle. I also like jars because I can mix my own custom colors for a particular painting and store them in separate jars. This is helpful if you are working on a large project and need to keep your colors consistent as you work.

For the projects in this book, I used a palette of eight colors: Alizarin Crimson, Burnt Umber, Cadmium Red Light, Cadmium Yellow Medium, Dioxazine Purple, Ivory Black, Prussian Blue and Titanium White. (For more information on palette colors and color mixing, see pages 20–21.)

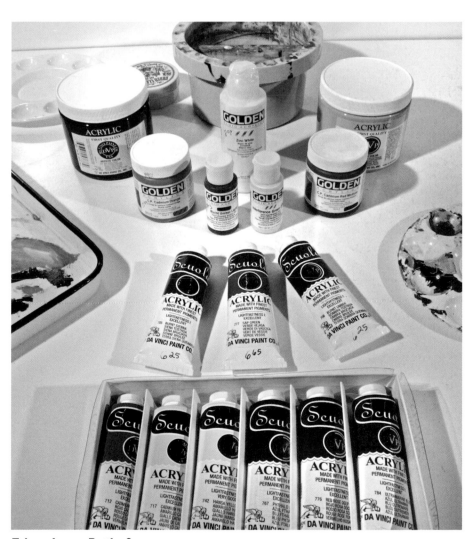

Tubes, Jars or Bottles?
Acrylic paints come in tubes, jars and squeeze bottles. I prefer to use the jars, so I can reuse leftover paint. I can also mix special colors for specific projects and place those colors in empty jars.

Paint Properties

As we just discussed, each form of paint—jar, tube or squeeze bottle—has different characteristics. Once you've selected the paint you prefer, you will find that individual colors have their own properties as well.

Opacity: Some colors will cover better than others, appearing more opaque, while some will be more transparent. With time and practice, you'll get to know your paints. Play and experiment first by creating some color swatches like the ones on this page. This will give you a better understanding of how each color on your palette behaves.

The swatches on this page show how some colors are opaque and completely cover the canvas, while others are more transparent and seem streaky.

Permanence: Certain colors are more prone to fading over time than others. Most brands will have a permanency rating on the package to let you know what to expect. A color with an *Excellent* rating is a durable color that will hold its original color for a long time. A color rated as *Good* or *Moderate* will have some fading, but not a huge difference over time. A color rated as *Fugitive* will tend to fade significantly. You can see this most often with yellows and certain reds. Try to avoid fugitive colors, but regardless of a color's permanence rating, never hang a painting in direct sunlight. Ultraviolet rays in sunlight are the primary cause of fading.

Toxicity: Good-quality paint brands will include some toxic colors. Some of the natural pigments that produce vivid colors are toxic, such as the Cadmium pigments and some blues. Never swallow or inhale these colors. Certain colors should never be spray applied; check the label. If you're working with children, always find a brand that substitutes synthetic, manufactured pigments for the toxic ones.

Don't Eat Your Paint

Because some colors are toxic, never hold brushes in your mouth. Also, use a jar or other distinctive container to hold water for painting so that you never mistake a cup of paint water for iced tea!

Prussian Blue + Titanium White
Just by adding a touch of Titanium White to Prussian Blue, you can create an opaque version of it.

Cadmium Red Light
This red is opaque and completely covers the canvas. Can you see the difference between this and the Alizarin Crimson?

Prussian Blue
This blue is dark but transparent.

Alizarin Crimson
This red is dark but transparent in nature. It has a streaky appearance, letting some of the canvas show through.

Thinned Acrylics: The Awkward Stage

Mixing acrylic paint with water makes it look transparent like watercolor. This is what I often do at the beginning stage of my painting, the Awkward Stage, to create the basic color patterns. Acrylic paint is waterproof when it dries (unlike watercolor pigments). You can add more color on top of acrylic without the color below pulling up or mixing in.

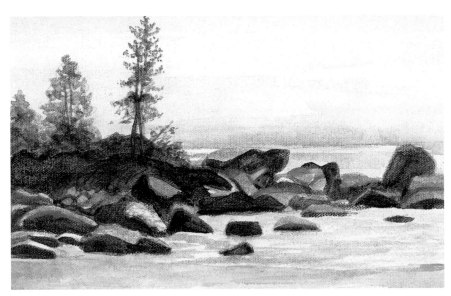

Thinned Acrylics
This example shows how important the transparent stage of a painting is. This is the Awkward Stage of a painting. By applying the paint thinly, I have a detailed map for applying the final coats. Thinned acrylics are also often used to create the look of watercolor paints.

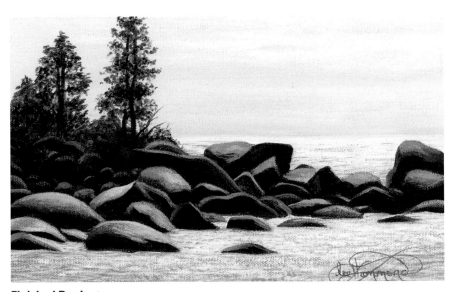

Finished Product
As you work your paintings, you'll reduce the amount of water in the paint, creating more opaque layers. The colors become much deeper, and they completely cover the canvas's surface.

Choosing Brushes

Read all about brush basics here, and see the list on page 10 for the basic set of brushes needed for the projects in this book.

Bristle Type
From top to bottom: stiff bristle, sable, squirrel hair, camel hair and synthetic bristle types.

Brush Shape
From top to bottom: flat, bright, round, filbert and liner brush shapes.

Bristle Type

The way paint looks when applied to canvas largely depends on the type of brush you use. Brushes come in a variety of bristle types.

Stiff bristle: These brushes are made from boar bristle, ox hair, horse-hair or other coarse animal hairs.

Sable: These brushes are made from the tail hair of the male kolinsky sable, which is found in Russia. This very soft hair creates smooth blends. The scarcity of the kolinsky makes these brushes expensive, but they are worth it!

Squirrel hair: These soft brushes are a bit fuller than sable brushes and are often used for watercolor because they hold a lot of moisture.

Camel hair: This is another soft hair that is used frequently for both acrylic and watercolor brushes.

Synthetic: Most synthetic bristles are nylon. They can be a more affordable substitute for natural-hair brushes, but paint is very hard on them. They tend to lose their shape and point faster than natural hair brushes. Good brush cleaning and care (see page 15) is essential to make synthetic brushes last.

Natural-hair brushes can be quite pricey. However, if cleaned properly, they will last longer than synthetic ones.

Brush Shape

Brushes come in different shapes, and some shapes are better for certain paint applications. Here is a quick list of the different brush shapes and the best uses for each.

Long or Short Brushes?

Long-handled brushes are designed for use while standing at an easel, so you can paint at arm's length and have a better overall view of your work. Short handles are better for painting while seated or for working on small details.

Flat: A flat brush is used for broad applications of paint. Its wide shape will cover a large area. The coarse boar-bristle type is a stiff brush that can be used to literally "scrub" the paint into the canvas. A softer sable or synthetic bristle is good for smooth blending with less-noticeable brush marks.

Bright: Brights are very similar to flats; however, the bristles are a bit longer, which gives the brush more spring.

Round: Use round brushes for details and smaller areas. The tip of a stiff bristle round is good for dabbing in paint or filling in small areas. A small soft round can be used in place of a liner brush for creating long straight or curved lines.

Filbert: This brush shape is my personal favorite. Also known as a *cat's tongue*, the filbert is useful for filling in areas, due to its rounded tip.

Liner: The liner's small, pointy shape makes it essential for detail work. You can create tiny lines and crisp edges with a liner.

Brush Maintenance

Acrylic paint is hard on brushes. Remember, once acrylic paint dries, it is waterproof and almost impossible to remove. Paint often gets into the brush's ferrule (the metal band that holds the bristles in place). If paint dries there, it can make the bristles break off or force them in unnatural directions. A brush left to dry with acrylic paint in it is as good as thrown away.

Follow these pointers to keep your brushes like new for as long as possible:

- Stick to a strict and thorough brush-cleaning routine. My favorite cleaning procedure is shown on this page. (Note: Some paint colors stain synthetic bristles. This staining is permanent, but normal and harmless.)

- Never leave a brush resting in a jar of water. This can bend the bristles permanently. It can also loosen the ferrule, causing the bristles to fall out. (Sometimes a brush with five hairs is good for small details, but not if the poor brush started out with a hundred!)

- Always store your brushes handle-down in a jar, can or brush holder to protect the bristles.

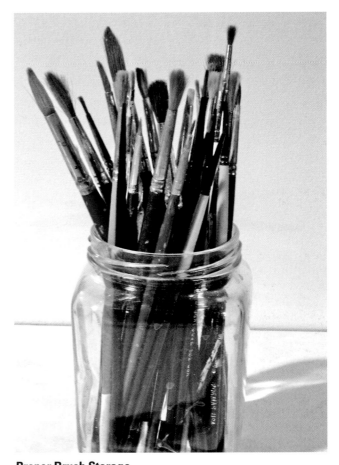

Proper Brush Storage
Always store brushes with their bristles in the *up* position!

How to Clean Brushes

1. Swish the brush in a jar of clean water to loosen any remaining paint.

2. Take the brush to the sink and run lukewarm water over it.

3. Work the brush into a cake of "The Masters" Brush Cleaner and Preserver until it forms a thick lather. At this point, you will notice some paint color leaving the brush.

4. Gently massage the bristles between your thumb and fingers to loosen the paint.

5. Rinse under the warm water.

6. Repeat steps 3 to 5 until no more color comes out.

7. When you are sure the brush is clean, apply some of the brush cleaner paste to the bristles and press them into their original shape. Allow the paste to dry on the brush. This keeps the bristles going the way they are intended and prevents them from drying out and fraying. It's like hair conditioner for your brushes! When you are ready to use the brush again, simply rinse the soap off with water.

My Favorite Brush Cleaner
"The Masters" Brush Cleaner and Preserver will remove all of the paint from your brushes and condition the bristles. I've used it for many years and swear by it.

Painting Surfaces

Many students ask me what the best painting surface is. That depends on your preference and what kind of painting you are doing. Acrylic paint can be used on everything from fine art canvases to wood, fabric, metal and glass. For the sake of this book, I will concentrate on surfaces normally used for paintings.

Stretched Canvas

Stretched canvas provides a professional look, making your work resemble an oil painting. Stretched canvas is easily framed and comes in standard frame sizes from mini (2" × 3" [5cm × 8cm]) to extra large (48" × 60" [122cm × 152cm] or larger). You will notice a bit of "bounce" when applying paint to stretched canvas.

Stretched canvas comes "primed," which means it is coated with a white acrylic called gesso to protect the raw canvas from the damaging effects of paint.

Stretched canvas can be regular cotton duck, excellent for most work; extra-smooth cotton, often used for portrait work; or linen, which is also smooth.

Canvas Panels

Canvas panels are canvas pieces glued onto cardboard backings. They are a good alternative to stretched canvas if you prefer to spend less. A canvas panel is very rigid and will not give you the bouncy feel of painting on stretched canvas.

With canvas panels, unlike stretched canvas, you have the option of framing with a mat. A colored mat can enhance the look of artwork. A canvas panel also allows you to protect your painting with glass.

Canvas Sheets

Another alternative is canvas sheets. Some brands are pieces of actual primed canvas, not affixed to anything. Others are processed papers with a canvas texture and a coating that resembles gesso. Both kinds can be purchased individually, in packages or in pads.

With canvas sheets, as with canvas panels, framing can be creative. Sheets are lightweight and easy to mat and frame. For the art in this book, I used mostly canvas sheets.

Painting Surfaces
Stretched canvas (1) is the most popular surface for fine art painting. It must go into a frame "as is" and is held into place with frame clips. These are metal brackets that snap over the wooden stretcher frames and grip the inside edge of the frame with sharp teeth.

Canvas panels (2) are canvas on cardboard backings. They are more rigid than stretched canvas, and the finished piece can be matted and framed.

Canvas sheets (3) can also be matted and framed. They are found in single sheets, packages and pads.

Palettes and Other Tools

The following items will make your painting experience more organized and pleasurable. None of them is expensive, and they can usually be found around the house.

Palettes

I prefer a plastic palette with a lid, multiple mixing wells and a center area for mixing larger amounts of paint. Because acrylic paint is a form of plastic, dried acrylic can be peeled or soaked from a plastic palette. I find this more economical than disposable paper palettes. I find a deviled egg plate a perfect palette due to the many "wells" and large size. It is easy to clean too.

So you don't have to spend a fortune on state-of-the-art materials. Many artists make their own palettes using old dinner plates, butcher's trays or foam egg cartons. You can use your creativity to make do with what is around you.

Other Tools

Cloth rags: Keep plenty of these handy. You can use one near your palette to wipe excess paint from your brush. You can also use them to wipe excess water from your brush as you paint, which keeps your painting from getting unexpectedly watered down by a loose drip. Paper towels work too, but can leave lint and debris.

Wet wipes: I usually have a container of wet wipes or baby wipes handy for cleaning my hands, my brushes or the floor if I drop paint.

Assorted containers: Collect jars, cans and plastic containers to use as water containers or for storing brushes.

Spray bottle of water: Use this to mist your paints to prevent them from drying out as you work.

Palette knife: This is useful for transferring acrylic paint to or from a jar as well as for mixing paint on your palette.

Masking or drafting tape: If you work with canvas sheets, you will need to tape them to a backing board as you work. Use drafting tape or easy-release masking tape to tape the edges of the sheet down. These kinds of tape will not damage or rip the sheet.

Palette Choices
Palettes come in many varieties. It is also easy to make your own with plates, egg cartons or plastic containers.

Additional Materials
Additional handy studio items, such as jars, plates, plastic trays, wet wipes and rags, can usually be found around the house.

2
Understanding Color

Color is the foundation for an entire painting. It doesn't have to be bright and vivid all of the time, but it does have to make some sense. Sometimes it can be so intense it almost jumps off the page. Sometimes color can be subtle and barely discernible. And there will be times when absence of color makes the painting what it is. Whichever the case may be, understanding color is what allows you to create these effects.

Color is really very scientific, so understanding the different hues and how they work together is important if you are an artist. Obviously there are many ways to use colors and even more ways to mix them. This chapter will guide you to doing both, which will help you to achieve magnificent landscapes. Behind each painting is the color wheel.

While I use a palette of only eight colors, my paintings contain hundreds of them through proper color mixing. This chapter will also introduce you to these eight colors and everything you can do with them.

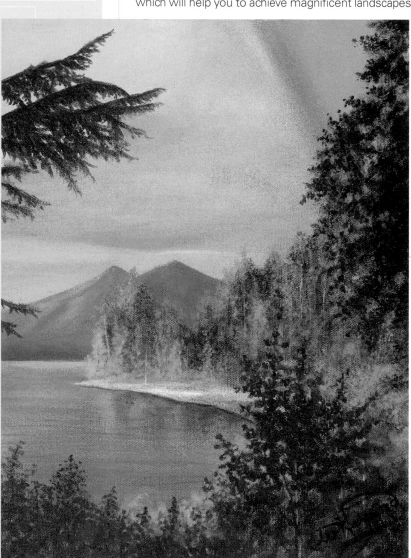

This is an example of how important color is to telling a story about the great outdoors. This piece is filled with colors of all kinds, ranging from the bright oranges and greens seen in the foliage, to the pastel, soft colors seen in the sky and rainbow. The addition of the black silhouette against these colors gives the painting a dramatic look and gives it a feeling of depth and distance.

THE END OF THE RAINBOW
12" × 9" (30cm × 23cm)

Colors Used: Alizarin Crimson, Burnt Umber, Cadmium Red Light, Cadmium Yellow Medium, Dioxazine Purple, Ivory Black, Prussian Blue and Titanium White

The Color Wheel

The color wheel is an essential tool for understanding and mixing color. Having one handy can help you pick out color schemes and see how different colors affect one another. For color mixing practice, create a color wheel of your own with the paints on your palette. Here are the basic color relationships to know.

Primary Colors: The primary colors are red, yellow and blue. They are also called the true colors. All other colors are created from these three. Look at the color wheel and see how they form a triangle if you connect them with a line.

Secondary Colors: Each secondary color is created by mixing two primaries together. Blue and yellow make green, red and blue make violet, and red and yellow make orange.

Tertiary Colors: Tertiary colors are created by mixing a primary color with the color next to it on the color wheel. For instance, mixing red and violet produces red-violet. Mixing blue with green makes blue-green, and mixing yellow with orange gives you yellow-orange.

Complementary Colors: Any two colors opposite each other on the color wheel are called complementary colors. Red and green, for example, are complements. The painting on the facing page is an example of a complementary color scheme used in a painting. The red and green contrast beautifully, each color making the other one really stand out.

Other Color Terms to Know

Hue: Hue simply means the name of a color. Red, blue and yellow are all hues.

Intensity: Intensity means how bright or dull a color is. Cadmium Yellow Medium, for instance, is bright and high intensity. Mixing Cadmium Yellow Medium with its complement, violet, creates a low-intensity version of yellow.

Temperature: Colors are either warm or cool. Warm colors are red, yellow and orange or any combination of those. When used in a painting, warm colors seem to come forward. Cool colors are blue, green and violet and all of their combinations. In a painting, cool colors will seem to recede.

Often there are warm and cool versions of the same hue. For instance, I use Cadmium Red Light and Alizarin Crimson. While both are in the red family, Cadmium Red Light is warm, with an orangey look, and Alizarin Crimson is cooler, because it leans toward the violet family.

Value: Value means the lightness or darkness of a color. Lightening a color either with white or by diluting it with water produces a *tint*. Deepening a color by mixing it with a darker color produces a *shade*. Using tints and shades together creates value contrast.

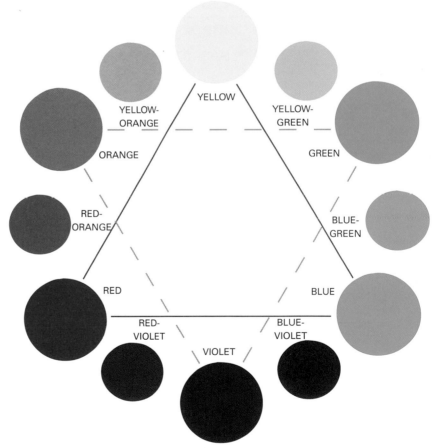

The Color Wheel

The color wheel is a valuable tool for learning color theory. Red, yellow and blue are the primary colors; orange, green and violet are the secondaries. The rest are called tertiaries.

Your Basic Palette and How to Expand It

With a basic palette of only eight colors, you can create
an endless array of color mixtures. Here are a few:

Three Primary Colors

| Cadmium Yellow Medium | Cadmium Red LIght | Prussian Blue |

Three Additional Colors

Alizarin Crimson Burnt Umber Dioxazine Purple

Two Neutral Colors

Ivory Black Titanium White

Tints
Mixing a palette color with white produces a tint.

Cad. Yellow + white = pale yellow Cad. Red + white = peachy coral Aliz. Crimson + white = pink

Burnt Umber + white = beige Prussian Blue + white = sky blue black + white = gray

Dioxazine Purple + white = lavender

Shades
Mixing a palette color with black produces a shade.

Dioxazine Purple + black = deep purple Cad. Yellow + black = dark olive green Cad. Red + black = maroon

Aliz. Crimson + black = plum Burnt Umber + black = dark brown Prussian Blue + black = dark blue

Cad. Red + Prussian Blue = maroon maroon mix + white = warm gray Aliz. Crimson + Prussian Blue = plum plum mix + white = lavender

Violets and Purples

Shades of violet and purple can be created by
mixing Cadmium Red Light and Prussian Blue
or Alizarin Crimson and Prussian Blue. Adding
white to these mixes will give you shades of
lavender, orchid, mauve and so on.

Greens

Greens can be difficult to mix due to the hundreds of possible variations. You can achieve green with yellow and blue, or with yellow and black. Adding brown yields an "earthy" green. Experiment as you go, and you'll find your favorites as well.

Cad. Yellow + black = olive green

olive green mix + white = grayish green

Prussian Blue + Cad. Yellow = green

blue/yellow mix + white = mint green

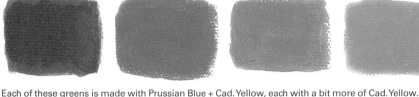

Each of these greens is made with Prussian Blue + Cad. Yellow, each with a bit more of Cad. Yellow.

Prussian Blue + Cad. Yellow + Cad. Red Light

Oranges

Cadmium Red Light or Alizarin Crimson mixed with Cadmium Yellow Medium will produce various shades of orange. Adding white to these colors will give you coral, peach, melon and so on.

Cad. Red + Cad. Yellow = orange

orange mix + white = peach

Aliz. Crimson + Cad. Yellow = orange-red

orange-red mix + white = coral

Earth Tones

Earth tones can be created by adding different colors into Burnt Umber. All of these colors can be turned into pastels by adding white. These swatches show the earth-tone mix (top swatch), and what it looks like with white added (bottom swatch).

Burnt Umber + yellow

Burnt Umber + red

Burnt Umber + blue

Burnt Umber + black

Burnt Umber + yellow + white

Burnt Umber + red + white

Burnt Umber + blue + white

Burnt Umber + black + white

Complementary Mixes

These three swatches were mixed using opposite colors from the color wheel. Notice that the last two use the same colors. The difference is in the amount used of each color. Experiment!

Dioxazine Purple + Cad. Yellow = violet-yellow

Cad. Yellow + Cad. Red Light + Prussian Blue = orange-blue

Cad. Red Light + Cad. Yellow + Prussian Blue = red-green

Color Schemes

In nature, color is everywhere. It shines down from the sky, bounces off the ground below and reflects in the water around us. Each piece of the earth carries a color, and it is up to us to capture it in our art. But colors change, and so do landscapes depending on the weather and the time of day. The same scene can look very different as a result.

Complementary

Complementary colors are colors that are opposite each other on the color wheel (see page 19).

When complementary colors are used near each other, they contrast with and intensify each other. When used in landscape paintings, they help create the feel of the environment and can create the look of separate seasons.

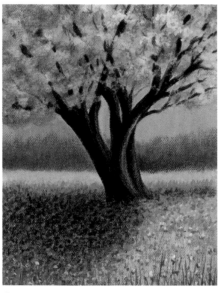

Complements: Yellow and Violet

Mixing Dioxazine Purple, rather than Ivory Black, with Cadmium Yellow Medium for this piece made a deep brown color for the bark of the tree and maintained the pure colors. The yellows look more vibrant against the violet, making the color scheme lend itself to the look of a spring scene with its light, warm look.

Colors Used: Cadmium Yellow Medium, Dioxazine Purple, Titanium White

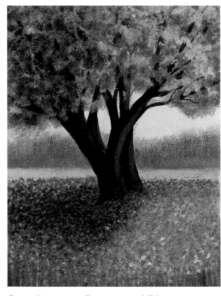

Complements: Orange and Blue

The orange/blue color scheme appears much richer and deeper, giving this more of an autumnlike appearance.

Colors Used: Cadmium Red Light, Cadmium Yellow Medium, Prussian Blue, Titanium White

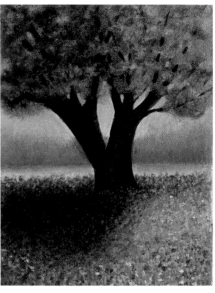

Complements: Green and Red

Red/green is intense and probably the most common scheme seen in nature. It resembles the look of a summer scene.

Colors Used: Alizarin Crimson, Cadmium Red Light, Cadmium Yellow Medium, Prussian Blue, Titanium White

Yellow + violet = pleasing shadow color

Yellow + black = green!

Monochromatic

When a painting is created using a variation of only one color, it is called monochromatic. I will often suggest to a student to try this type of painting first as an introduction to painting. By using just black and white, for instance, they can concentrate on technique without having to think about the colors.

Triadic

A triadic color scheme uses three colors that are evenly spaced around the color wheel. A triadic scheme always provides wonderful contrast, yet the colors are still harmonious. It also has complementary color aspects.

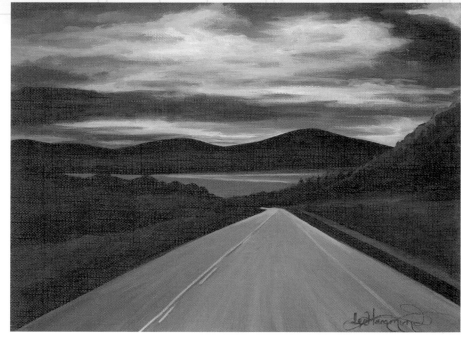

TRIP TO LAKE GEORGE
9" × 12" (23cm × 30cm)

This scene is an example of a monochromatic color scheme. Even with no color at all, this is a beautiful painting.

Colors Used: Ivory Black and Titanium White

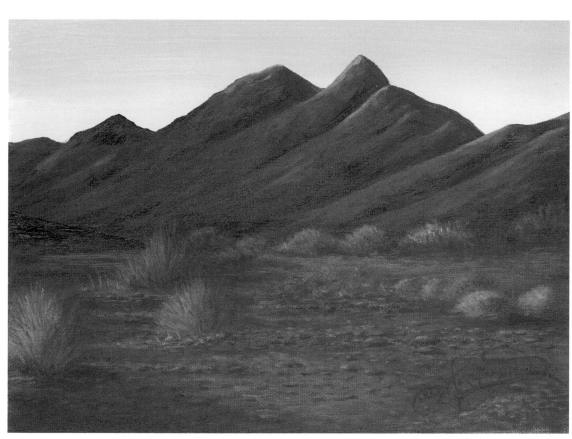

ARIZONA SUNRISE
9" × 12" (23cm × 30cm)

This painting uses orange, violet and green. It is very dramatic in the use of color as well as the contrasts.

Colors Used: Alizarin Crimson, Burnt Umber, Cadmium Red Light, Cadmium Yellow Medium, Dioxazine Purple, Ivory Black, Prussian Blue and Titanium White

3

Basic Techniques

Learning something new is always a bit intimidating. As with anything else, the best teacher is just plain experience—trial and error. This chapter will show you how to grab a brush, dip it in the paint and experiment. In no time you should feel comfortable enough to try the projects in the book for acrylic paint is highly forgiving. If you don't like something, you can simply cover it up!

Try the exercises in this chapter to get a feel for flat, filbert, round and liner brushes and how they are used. Learn the five elements of shading and how to use them to create the illusion of form on a flat canvas. You will then be ready to move ahead to the larger projects in the book.

Blending With a Flat Brush

Flat brushes are most commonly used for applying large areas of color and for creating blended backgrounds.

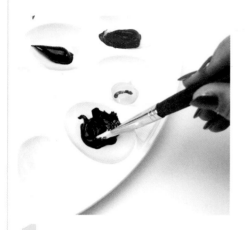

1 Load a flat brush with your first color from the palette.

2 Apply the first color to the canvas and stroke up and down.

3 Pick up white on your dirty brush.

4 Apply the white on top of, and overlapping, the first color on your canvas.

5 Clean your brush, then stroke up and down to blend out the two colors on your canvas. This blending takes practice, so don't get frustrated.

Blending With a Filbert Brush

A filbert brush is very similar to a flat, but the tip of it is rounded, much like the shape of a tongue. That's why this brush is sometimes called a cat's tongue. I like to use a filbert for almost any shape that requires filling in. The rounded edges are nice for going around curved edges.

1 Load a filbert brush with your first color from the palette.

2 Apply the first color to your canvas and stroke up and down.

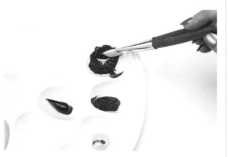

3 Pick up the second color and blend it with the first color on your palette.

4 Apply the mixed color on top of, and overlapping, the first color on your canvas.

5 Pick up white from the palette using the dirty brush.

6 Apply the white directly to the lightest color area on the canvas.

7 Stroke up and down to blend out the colors on your canvas.

Exercise
Pulling With a Liner Brush

Pointed brushes such as rounds and liners are excellent for creating lines and small details. They come in a variety of sizes and are essential for painting things like trees, grass, hair and fur. They are also good for making small dots for highlights and textures. Use rounds and liners on their tips. Don't place a lot of pressure on them because the bristles will bend over.

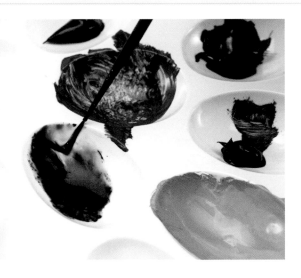

1 Using a liner brush requires the paint to be thinned with water to an inky consistency. To thin, add a few drops of water to the color on your palette and load your liner brush with the thinned paint.

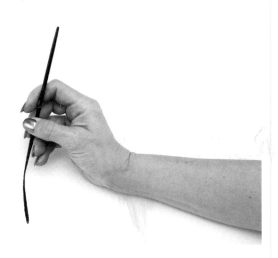

2 To get smooth, even strokes, start at the bottom and begin pulling a fine line upward.

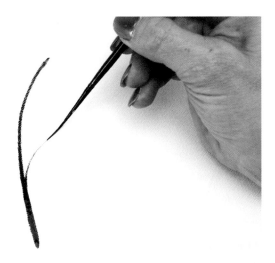

3 Continue the upward motion and let the end of the line taper off. If you try to paint another line without reloading, the line will break, so keep plenty of thinned paint in your brush.

Creating Texture

There are many ways to create texture with acrylic paint.

- **Drybrushing** creates a rough, textured appearance because the paint is used so sparingly that it doesn't fully cover the canvas.
- **Sponging** is great for creating textures such as distant foliage.
- **Stippling/Dabbing** is great for creating the look of volume.

Drybrushing

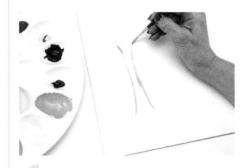 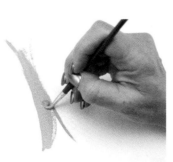 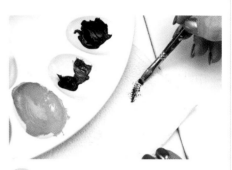

1 Using a round brush, outline the shape with your base color mix. Here I'm using a mixture of brown and white for a tree trunk.

2 Fill in the shape with the same round brush. Let this dry completely before going on so that the base color isn't lifted.

3 Switch to a small, flat bristle brush that's been well used (a *scrubby* brush). Pick up a small amount of your dark color from the palette. Wipe off some of this color on a paper towel to make your brush as dry as possible.

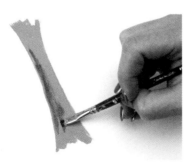 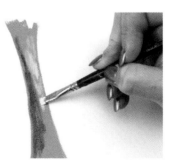

4 On the shaded side of the shape, scrub the dark color on as if you were drawing.

5 Clean the scrubby brush with water, and blot on a paper towel until the brush is barely damp. Pick up a small amount of your light color from the palette. Wipe off some of it on a paper towel. Scrub the light color on the highlighted side of the shape.

Stippling/Dabbing With a Brush

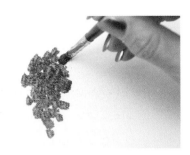

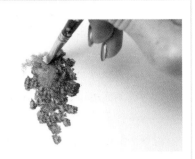

1 Using a small, soft-bristle flat brush, apply your first color to the canvas with a dabbing motion.

2 Switch to a small, flat scrubby brush, and dab a lighter color on top, letting some of the first color show through.

Stippling/Dabbing With a Kitchen Sponge

1 Tear off a small part of a cellulose kitchen sponge (the kind with uneven, random-sized holes).

2 Pick up some of your first color on one end of the sponge piece.

3 Dab the color lightly on the canvas for a lacy, airy look.

4 Pick up some of your second, lighter color on the same sponge.

5 Dab the lighter color lightly over the first color, letting some of the darker color show through.

A Closer Look

Analyze this landscape and you will see all of the techniques and brush strokes we have covered so far. Each area of this painting was created in a unique approach due to the varied textures found in nature. This is important, so study the examples closely.

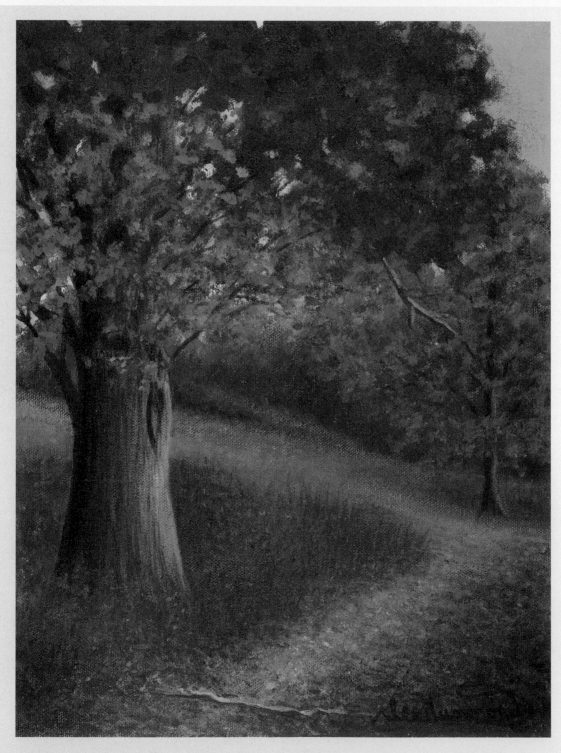

I used my entire palette to create the colors in this piece, mixing colors as I went along.

AUTUMN AT THE PARK
12" × 9" (30cm × 23cm)

Colors Used: Alizarin Crimson, Burnt Umber, Cadmium Red Light, Cadmium Yellow Medium, Dioxazine Purple, Ivory Black, Prussian Blue and Titanium White

Blending

Even though you do not see very much of it, it is important to have the entire sky area filled in with a smooth, blended application first. This is the foundation for everything else to go on top of. You can see it peeking through the foliage of the tree.

Dry-Brush Layering

These textures were created with a small round brush and quick, vertical strokes. Dry-brushing makes the rough texture. Layering light and dark colors over one another with this method gives the look of tree bark.

Dabbing

The foliage was created with a round brush and a dabbing motion. Small pieces of a cellulose kitchen sponge show more variation and make some of the smaller texture on top. Dabbing blobs of contrasting color creates the look of full leaves.

Pulling

In between the foliage you can see very small limbs that were created with the pulling technique (see page 27) and a small liner brush. See how the lines seem to go in and out of the foliage?

Combination Techniques

There will be times when you will have to use a combination of techniques to create a certain look. The grassy areas of this painting are a good example of this. After painting in the ground with a yellow-green color and a flat brush, I added some small, quick strokes with a liner for the blades of grass. I used a darker color of green for contrast. I then added texture to make it look more real by dabbing multiple layers of color with a small piece of sponge. Change the sponge periodically, and use different edges to prevent a repetitive pattern from being produced.

The Five Elements of Shading

I firmly believe that the foundation for any realistic rendering, regardless of the medium, can be found in the five elements of shading on the sphere. I begin each and every book I write with this, and start every new student with this valuable lesson. If you can create a believable and realistic depiction of a sphere (for example, a ball on a table), the ability to render everything else is right at your fingertips.

When rendering a sphere, each of the five elements will correspond with a shade on a value scale. The sphere on this page has been created using a monochromatic color scheme of Burnt Umber and Titanium White. The paint swatches beneath the sphere correspond with the five elements of shading. Use these different tones as a guide.

1 **Full Light:** This is the white highlight area, where the light source is hitting the sphere at full strength.

2 **Reflected Light:** This is a light gray. Reflected light is always found along the edge of an object and separates the darkness of the shadow edge from the darkness of the cast shadow.

3 **Halftone:** This is a medium gray. It's the area of the sphere that's in neither direct light nor shadow.

4 **Shadow Edge:** This dark gray is not at the very edge of the object. It is opposite the light source where the sphere curves away from you.

5 **Cast Shadow:** This is the darkest tone on your drawing. It is always opposite the light source. In the case of the sphere, it is underneath, where the sphere meets the surface. This area is void of light because as the sphere protrudes, it blocks light and casts a shadow.

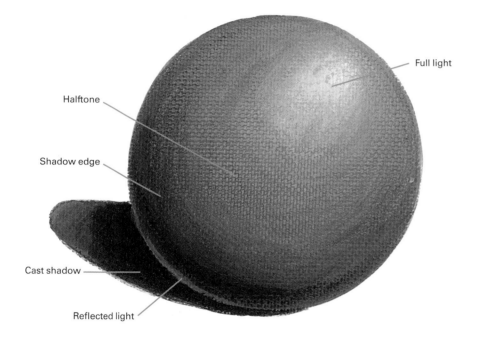

Halftone

Full light

Shadow edge

Cast shadow

Reflected light

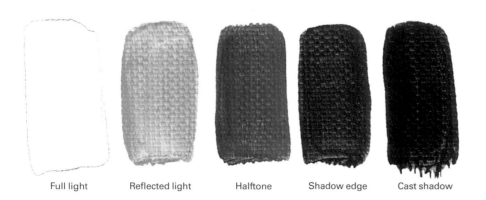

Full light Reflected light Halftone Shadow edge Cast shadow

Exercise
Five Elements of Shading: Sphere

Let's paint this sphere together using Ivory Black and Titanium White.

Identify where the five elements of shading (see page 32) will be, and look at the value scale shown in step 1. Look and see how the value scale with the brown tones compares with the gray tones. It is important to make the depth of tone for each box the same for both. For example, the #3 brown tones should be the same value, or darkness, as the #3 in gray. If the brown scale were copied on a black-and-white photocopier, it would look the same as the scale on this page.

MATERIALS LIST

PAINTS
Ivory Black and Titanium White

BRUSHES
No. 4 sable or synthetic round, no. 6 sable or synthetic filbert

OTHER
Mechanical pencil, straightedge

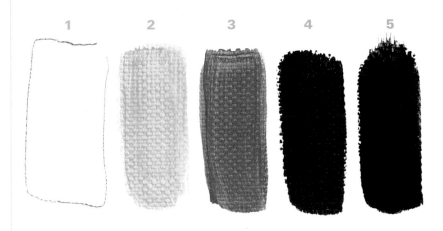

1 Mix Your Colors

Value #5 is pure Ivory Black. Mix a very small amount of Titanium White with Ivory Black until you match the #4 dark gray. When you are happy with your color, take some of the dark gray, and mix a little more Titanium White into that to create the #3 halftone. Add some more white to that to create the #2 light gray. Value #1 is pure Titanium White.

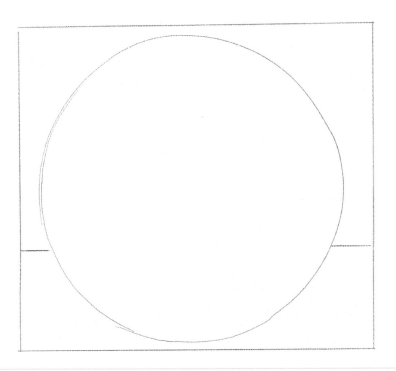

2 Draw the Circle

With a mechanical pencil, trace a perfect circle onto your canvas paper. With a straightedge, create a border box around the sphere, then draw a horizontal line behind the sphere. This will represent a table top and give the illusion of a background area.

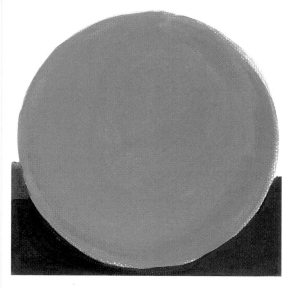

3 Paint the Base Colors

With a dark gray that matches the #4 on your value scale, base in the table top with a no. 4 round. This brush is pointy and can get into the corner and go around the curved surface easily. This deep gray will give us a foundation to build the rest of the painting on.

To paint the sphere, begin with the darkest area first. In this case, it is under the sphere in the cast shadow. Use the Ivory Black full strength (#5 on the value scale) to create the cast shadow over the dark gray. Use the same no. 4 round.

Switch to the no. 6 soft filbert, and fill in the entire sphere with a medium gray mixture. This should match the #3 on the value scale. Be sure to completely fill in the sphere so there is no canvas showing through.

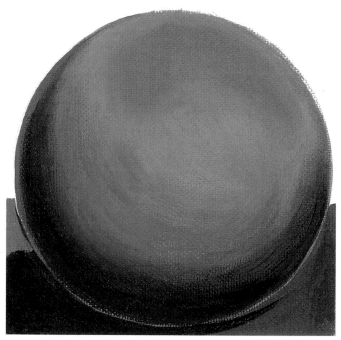

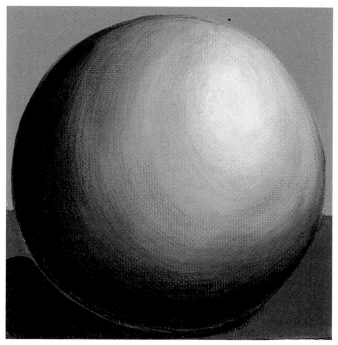

4 The Awkward Stage

With the #4 dark gray mixture, apply the shadow edge of the sphere with a no. 6 soft filbert while the medium gray paint is still wet. The filbert will blend the tones together. Make sure the shadow is parallel to the edge of the sphere, allowing the two colors to blend. Allow the dark gray to show along the edge of the sphere, creating the reflected light.

While the paint is still wet, add some of the medium gray mixture above the dark gray, and blend the two using long rounded strokes that follow the contours of the sphere to create the halftone area. Blend until the tonal transitions are smooth.

5 Finish

With Titanium White, apply the full light area and blend it into the halftone using a no. 6 filbert. To make the light area stand out, apply some of the medium gray mixture behind the sphere to create the background. The light edge of the sphere contrasts against it.

This is not as easy as it looks, so please do not get frustrated. Remember, you can go over things as many times as you want. I often will add some paint and softly reblend into the paint that is already there. I can spend a lot of time trying to get it just right. This is all part of the challenge!

Create Spheres Using Complementary Colors

Practice painting the monochromatic sphere from the previous exercise. It really is the foundation for everything else you'll paint. When you feel you've got it, try painting spheres in color.

Remember the five values you created on pages 32 and 33? For spheres in color, the main color of your sphere is a #3 on the value scale. Mix the lighter values (#1 and #2) by adding Titanium White. Mix the darker values (#4 and #5) by adding the comple- ment of the main color. Complements produce a pleasing grayed-down color, perfect for painting shadows.

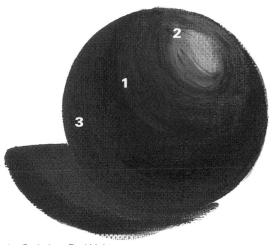

1 Cadmium Red Light
2 Cadmium Red Light mixed with Titanium White
3 Cadmium Red Light mixed with green (Prussian Blue + Cadmium Yellow Medium)

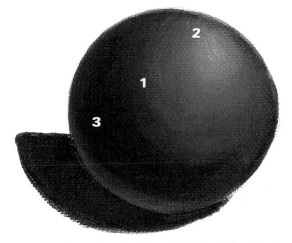

1 Green (Prussian Blue + Cadmium Yellow Medium)
2 Green mixed with Titanium White
3 Green mixed with Cadmium Red Light

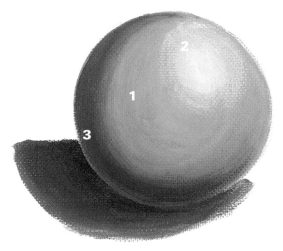

1 Cadmium Yellow Medium
2 Cadmium Yellow Medium mixed with Titanium White
3 Cadmium Yellow Medium mixed with Violet (Alizarin Crimson + Prussian Blue)

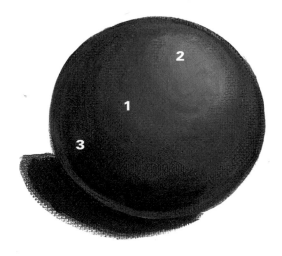

1 Prussian Blue
2 Prussian Blue mixed with Titanium White
3 Prussian Blue mixed with orange (Cadmium Yellow Medium + Cadmium Red Light)

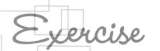

Five Elements of Shading: Other Shapes

While the sphere is the core shape for learning form, there are other important shapes that apply to landscapes.

The cylinder is found in the shapes of tree trunks; it would be impossible to paint realistic trees without a good understanding of it. The long cylinder or tube is also seen in the limbs and branches of trees. The cone is also an important shape, as it is the basic shape seen in mountains and pine trees.

MATERIALS LIST

PAINTS
Burnt Umber, Ivory Black and Titanium White

BRUSHES
No. 2 flat or filbert, no. 2 round, no. 2 round sable or synthetic

OTHER
Mechanical pencil

Cone

1 Shape
Lightly sketch in the shape of the cone. Be sure the point is centered and that the sides are equidistant all of the way down. Make the bottom slightly curved; do not draw it straight across. With black and white mixed together to create a medium gray, fill in the cone with a no. 2 flat or filbert.

2 Cast Shadow, Shadow Edge, Highlight Areas
Add the cast shadow going off to the left with pure black and a no. 2 round sable or synthetic. With black, drybrush the shadow edge along the left side with the same brush. With white, do the same on the right for the highlight area.

3 Finish
Soften all the tones by drybrushing the colors together. By taking the gray color and drybrushing it into the dark shadow edges, the tones transition together. Drybrush pure white into the highlight area down the side with a small flat or filbert. Fill in the cast shadow with pure black to make it solid and opaque.

Cylinder

1 Begin

Lightly sketch in the shape of the cylinder. Curve the elliptical shape at the top along the edges with no points. Make the sides vertical and parallel. Using Burnt Umber, fill in the cast shadow area to the left with a no. 2 round sable or synthetic. Here, the light comes from the front right. Add some white to the Burnt Umber to lighten and fill in the entire shape with a no. 2 flat or filbert. Create a darker shade by adding more Burnt Umber, and paint the edge along the top with a no. 2 round. Add more white to the brown mix and fill in the area below and around the cylinder.

2 Shadow Edges and Top

With the darker color, add the shadow edges to the sides with a no. 2 flat or filbert. Add more of this darker color along the front edge of the top, allowing the back side to remain lighter. Add a small cast shadow to the right side with a no. 2 round.

3 Finish

Add highlight areas to the cylinder, and extend the table top.

Soften all the tones by drybrushing the colors together. Drybrush the light brown color into the dark shadow edges to transition the tones. Drybrush pure white into the highlight area down the front with a small flat brush or filbert to finish. Add some white to the back half of the cylinder's top. Extend the table top with the light brown color. Repeat the process for the long cylinder. This one does not have a cast shadow to deal with.

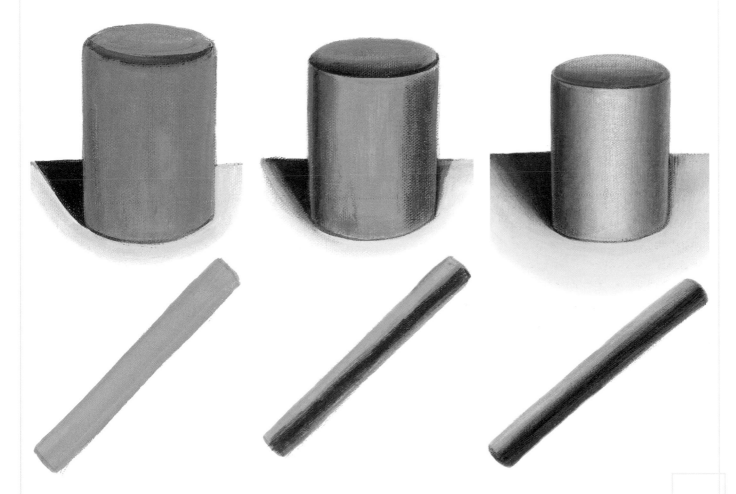

4

Composing Your Paintings

When composing landscapes, I always go from back to front. Scenery is built in layers, starting with the sky first, and then going from middle to foreground in stages. Everything must be finished in the back before painting anything in the front. The following pages will introduce you to the other composition do's I tend to use. You must always decide what element of your painting is the most important and alter the composition to place the emphasis on that element.

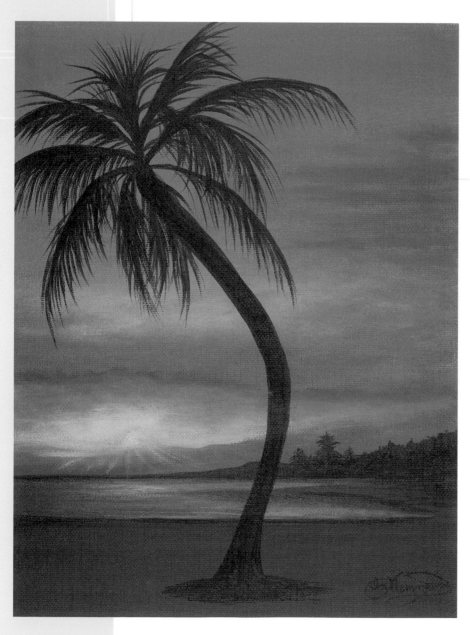

PUERTO VALLARTA SUNSET
12" × 9" (30cm × 23cm)

Colors Used: Alizarin Crimson, Cadmium Red Light, Cadmium Yellow Medium, Dioxazine Purple, Ivory Black, Prussian Blue and Titanium White

Horizon Line

Since we will always be starting from the back, it is important to know where the background ends and the foreground begins. Drawing a simple horizon line can help you get your perspective on the composition.

In the beach scene on the previous page, the horizon line is toward the bottom, which allows room for the beauty of the sky. The composition should never be divided right in half. It will ultimately end up destroying the balance of the painting, since the focal point will be divided equally, thereby placing the focus on nothing. A horizon line high on the page places the focus of the painting in the foreground. The amount of sky is reduced.

1 Horizon line

2 Sky area

3 Ground or water area

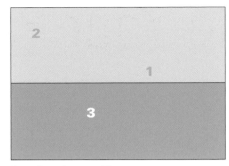
An awkward composition

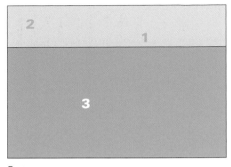
Better

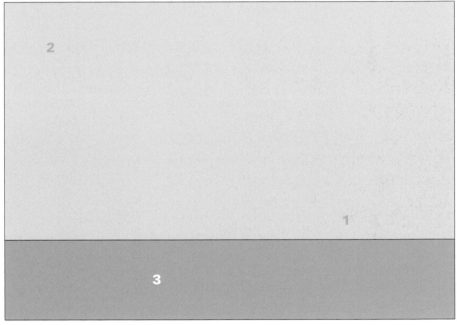
Better

Horizon Line Placement

Outdoor scenes start with a simple horizon line (1). This is where the sky (2) and the ground or water (3) meet. As a general rule for any landscape, be careful not to cut your composition exactly in half with the horizon line. If you do, the viewer's eye won't know what to focus on first. Place the horizon line either above the middle of your canvas (to emphasize the ground or water area) or below it (to emphasize the sky area).

Composition Examples

When we talk about composition, we're simply talking about how the elements of your painting are arranged on the surface. Since composition can vary, let's study some examples.

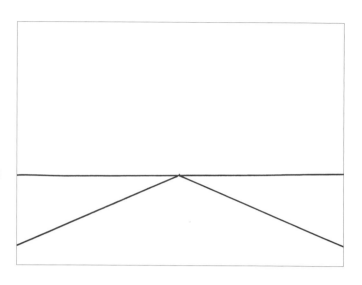

Converging Lines

One of my personal favorites is the converging lines composition, where a road or path gets smaller as it nears the horizon line. This type of composition creates an extreme illusion of depth and distance, making the eye and the imagination search for even more.

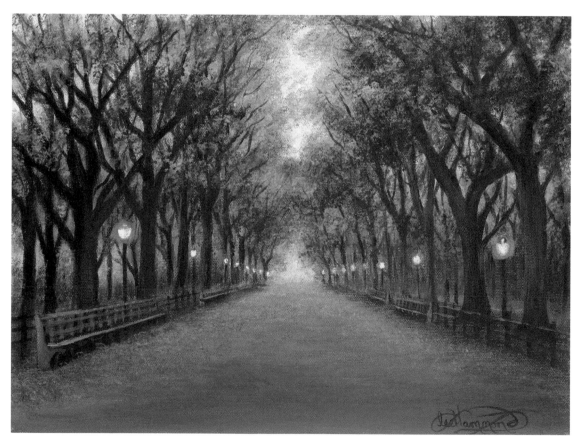

CENTRAL PARK
9" × 12" (23cm × 30cm)

Colors Used: Alizarin Crimson, Burnt Umber, Cadmium Red Light, Cadmium Yellow Medium, Dioxazine Purple, Ivory Black, Prussian Blue and Titanium White

Converging Lines in Action

One-point perspective creates a converging line composition. This example is one of those pieces. Simple lines make up the composition. The walkway creates an extreme upside-down V shape. These lines come together and meet at a common point along the horizon line. Because of the converging composition, it pulls you into the picture, making you imagine what is there beyond the horizon line.

Off-Center Converging Composition

A converging composition does not have to be perfectly centered. Sometimes the lines of convergence can be off center to create a different vantage point. Look at this diagram and you can see where the perspective lines meet at the horizon line.

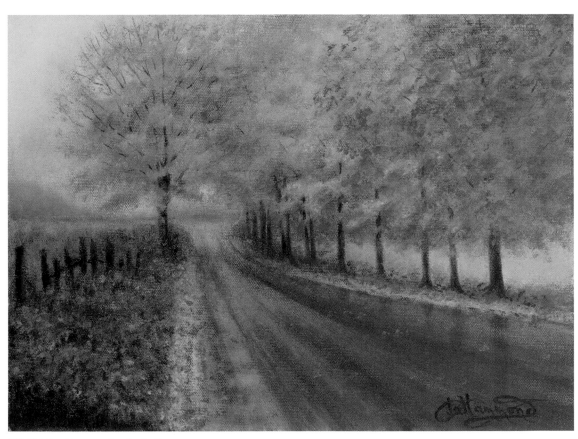

MISTY MORNING WALK
9" × 12" (23cm × 30cm)

Colors Used: Burnt Umber, Cadmium Red Light, Cadmium Yellow Medium, Dioxazine Purple, Ivory Black, Prussian Blue and Titanium White

Off-Center Converging in Action

The off-centered road makes room for the row of trees on the right, but the hill and the tree on the left balance the weight of the composition. Weight, which is made up of the size and tone of an object, is extremely important to composition. If certain masses are too large and not offset by another large mass in another area, the entire painting can look lopsided or confusing. Look at the all the areas, not just the subjects. A sky area has just as much weight as a mountain when it comes to composition!

S-Curve

This is my ultimate favorite of the compositions. It does the same thing as the examples before, where the lines of composition diminish to a common point on the horizon line. But with an S-curve, the lines are curved and often interrupted, going in and out of the landscape, sometimes disappearing behind something altogether.

This type of composition actually pulls your eye around the painting.

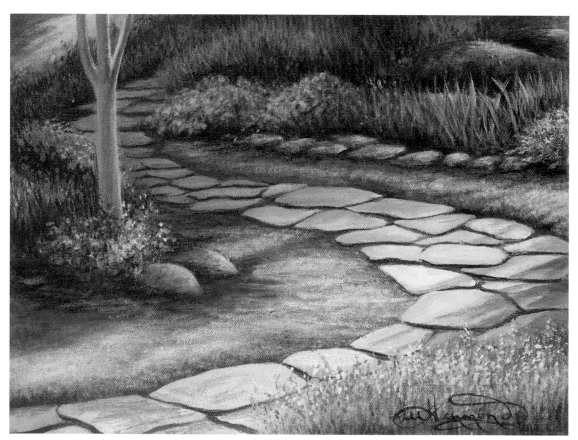

GARDEN WALKWAY
9" × 12" (23cm × 30cm)

Colors Used: Alizarin Crimson, Burnt Umber, Cadmium Red Light, Cadmium Yellow Medium, Dioxazine Purple, Ivory Black, Prussian Blue and Titanium White

S-Curve in Action

The curve of the walkway divides the painting into equal parts, giving each part of the painting a feeling of importance. In this piece, the focal point is first the walkway, then the flowers, all of them. You start with the ones in the foreground and then visually follow the path around the garden to see the rest. This type of painting makes you work a little bit as you view it. It becomes a guided tour of the painting, leading the eye around the picture plane.

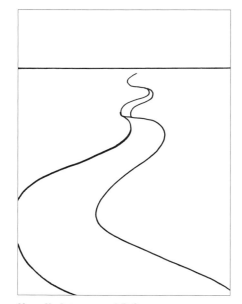

Heavily Interrupted S-Curve

You can see how the lines of this composition resemble the look of a ribbon winding up to the horizon line, going in and out of the scenery. This type of gentle curve makes for an interesting painting. The interrupted line gives an illusion of hidden space and unseen areas. It makes your imagination take over to fill in the blanks.

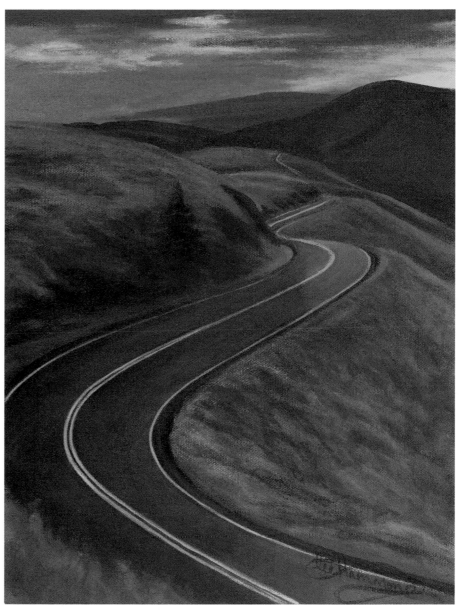

Heavily Interrupted S-Curve in Action

The winding highway gently leads you through the hills to the warm sun setting on the horizon. Compare this composition to the one of the garden walkway. The way the S-curves go in and out of this painting gives it much more of an illusion of distance, with the pavement getting smaller and smaller as it gradually disappears. The garden path remains large, meaning it is closer to us. The highway, on the other hand, becomes so small it actually disappears into the hills. It creates the look of miles, not yards.

WINDING SUNSET HIGHWAY
12" × 9" (30cm × 23cm)

Colors Used: Alizarin Crimson, Burnt Umber, Cadmium Red Light, Cadmium Yellow Medium, Dioxazine Purple, Ivory Black, Prussian Blue and Titanium White

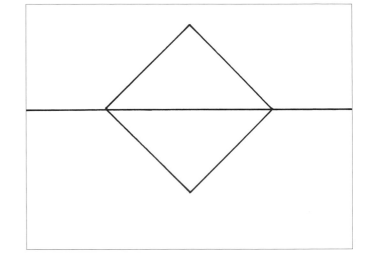

Mirror Image

When water is involved in a landscape painting, often the composition is altered due to reflections that are created. The water acts like a mirror, reflecting the images upside down below them. The dual images balance the weight of the composition. This type of landscape is very common.

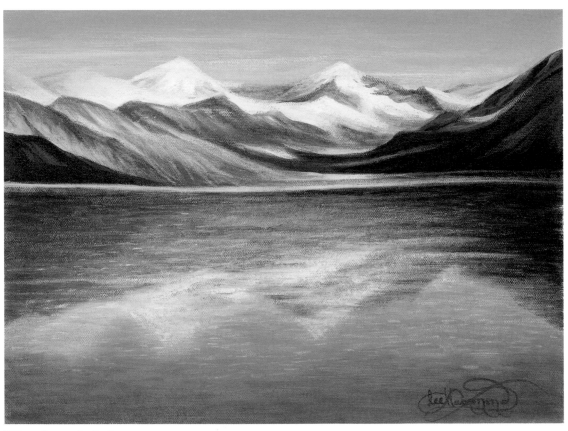

ICY MOUNTAIN REFLECTION
9" × 12" (23cm × 30cm)

Colors Used: Alizarin Crimson, Dioxazine Purple, Ivory Black, Prussian Blue and Titanium White

Mirror Image in Action

The top and the bottom of this painting look very similar. To make it discernible, of which is up and which is down, the image reflected in the water is not as sharp, appearing a bit out of focus. The shapes in the reflection are also interrupted by the movement of the water's surface, making them appear broken up. You can see how the ice in the water breaks up the reflections. With any reflections, you must not confuse them with shadows. Shadows will move according to the light source. Sometimes they stretch out or go off to the side, depending on the strength of the light. Reflections, however, are always directly below the subject being reflected no matter what the light is doing. In this painting, you can see each mountain peak reflecting directly below in the water. It is always a direct vertical. With a mirror-image composition it is important to take the horizon line out of the middle. In this piece, I moved it above center to allow a bit more room below in the water area. If the sky had been more dramatic, I could have moved it below center to put more focus there.

Composition Checklist

Look through the pages of this book and see how each piece is handled. The most important thing to remember about composition is balance.

Think about the following as you lay out your paintings:

- **Balance.** Be sure the weight and size of the shapes and elements are evenly distributed and not all on one side. Offset your horizon line so it doesn't appear too top or bottom heavy.

- **Color and Value.** Be sure the colors and tones are evenly distributed. Too much light or dark in an area can throw off a composition. Colors should repeat around the page.

- **Pathway.** I like all the elements in my paintings to come together to lead the eye around the painting, and then back to center.

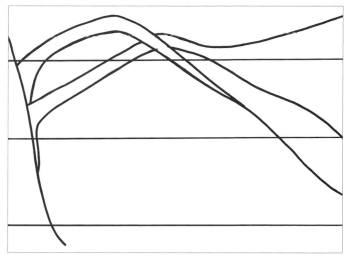

Balance
This line drawing is an example of good compositional balance.

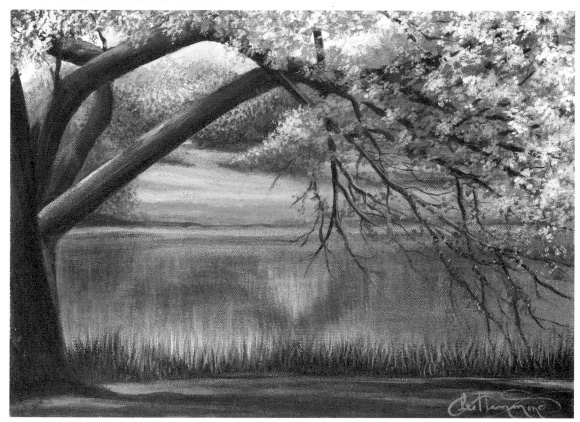

**SPRINGTIME
REFLECTIONS**
9" × 12" (23cm × 30cm)

Colors Used: Alizarin Crimson, Burnt Umber, Cadmium Red Light, Cadmium Yellow Medium, Dioxazine Purple, Ivory Black, Prussian Blue and Titanium White

Balance in Action
The horizon line is above center, (it is the top of the hill, not the water's edge) with a mirror image of the colors of the trees reflecting below. The shapes of the large tree in the foreground act as a natural framework, leading the eye around the canvas. Look at how the weight of the tree trunk and branches on the left side is offset by the mass of flowers in the corner on the right side. It is a good distribution of compositional weight.

Using Thumbnail Sketches

We've seen how a good composition can look; now let's look at ones that aren't so good. Being able to see the problems in the early stages is very important, for once you start to paint, it may be difficult to remedy. One way of creating a good composition is to create some thumbnail sketches first, before you begin to paint. Sketch out the elements of your painting on a piece of paper and experiment with their placement. I have selected three compositional items most often seen in landscape painting: the sky, some trees and a mountain. With only three items, it may seem as if it would be easy to balance and distribute them around the canvas, right? Not so fast! Here are some line drawings to show you what can go wrong.

Too Centered and Crowded

This composition is balanced when it comes to the weight of the objects, but it still doesn't work. Everything seems to be too centered and it looks crowded. By placing the mountain so close to the top, there isn't much room for any sky effects either.

Lopsided

This time I turned the mountain into more of a hill to give myself some more room in the sky. To offset it, I moved the trees over to the right, but this doesn't work either. Now it looks lopsided!

Off Balance

This one is a lot better, but it doesn't work either! I like the placement of the mountain and the slight hill in the foreground, but the placement of the trees bothers me. The one in the middle throws the balance off!

My Favorite

I moved the trees a little and completely removed the one in the middle. Now it looks roomy, and the weight of the layout is evenly distributed. This is definitely something that I can work with.

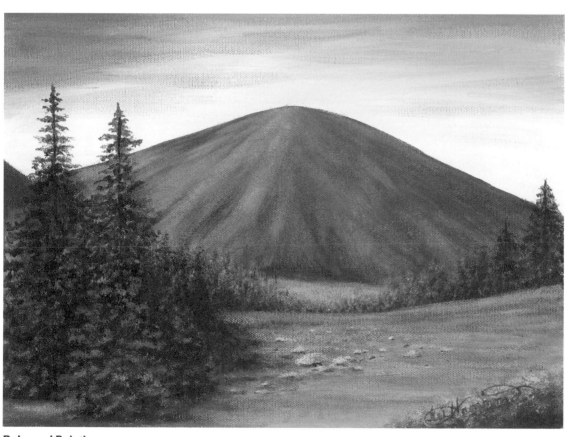

MOUNTAIN MEADOW
9" × 12" (23cm × 30cm)

Colors Used: Alizarin Crimson, Cadmium Yellow Medium, Dioxazine Purple, Ivory Black, Prussian Blue and Titanium White

Balanced Painting

The darkness of the trees on the left is balanced by the trees on the right, and the small bush in the lower right corner. Even though the mountain is centered, the horizon line is below center in the grass. The deep violet color of the sky in each corner helps offset the weight of the mountain.

There is some color balance going on here as well. The light side of the mountain (on the left) makes the darkness of the trees stand out. The dark side of the mountain (on the right) makes the light stand out in the grassy area. Look for these things when choosing how to arrange your next painting.

5

Landscape Elements and Techniques

Landscape paintings are made up of several different elements: skies, foliage, trees, grasses, flowers, rocks, mountains, hills, water, atmosphere effects. The possible combinations are endless! In this chapter, I'll show you my techniques for painting these individual elements, step by step.

INCREDIBLE SUNSET!
16" × 12" (41cm × 30cm)

Colors Used: Alizarin Crimson, Burnt Umber, Cadmium Red Light, Cadmium Yellow Medium, Dioxazine Purple, Ivory Black, Prussian Blue and Titanium White

Atmospheric Perspective

Landscapes are made up of layers that create depth and the illusion of distance. When painting them, it is important to start with the background first and work forward from there. Everything is built from back to front. Things can then overlap, creating layers and the look of distance.

Atmosphere is an incredibly important element when taking on the job of painting landscapes. Atmosphere is not just the way the sky looks, but the way the surroundings appear. The sky is the vehicle for weather, and the weather affects everything it touches. These two examples show you how atmosphere can alter the way we look at things. When looking into the distance, things farther away will appear to become lighter in value. This is because layers of the atmosphere are placed between you and the horizon. The farther away something is, the more it will take on the sky color.

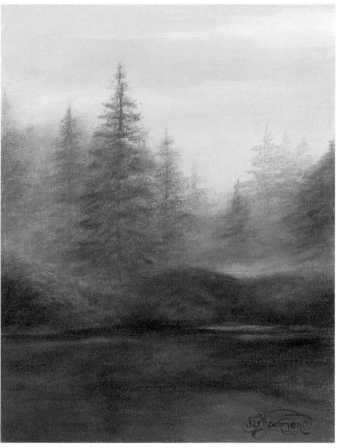

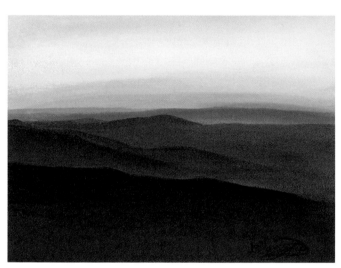

More Sky Color = Distance

Here, the illusion of distance is created by the color of the hills. Notice how much lighter they get as they go back. In this complementary color scheme, the distant layers take on more of the yellow tones from the sky, making them fade into the sunset. The colors go from a rich, deep violet in the foreground, to a shade of orange in the background, all due to the color of the sky and the distance between each hill.

ARIZONA HILLS
9" × 12" (23cm × 30cm)

Colors Used: Alizarin Crimson, Burnt Umber, Cadmium Red Light, Cadmium Yellow Medium, Dioxazine Purple, Ivory Black, Prussian Blue and Titanium White

Fewer Details = Distance

The farther away the pine trees are, the more of the sky color they take on. Each one becomes a bit lighter as they go back. With distance and atmosphere, you also lose details. The farther away something is, the fewer details you will see.

MISTY PINES
12" × 9" (30cm × 23cm)

Colors Used: Burnt Umber, Cadmium Yellow Medium, Dioxazine Purple, Ivory Black, Prussian Blue and Titanium White

Skies: Cloud Types

There are many cloud types. Each one has certain characteristics and appearances. They are found in the various layers of the atmosphere, and each layer has its own type of cloud. It is not unusual to see different cloud types floating together depending on the weather condition that is producing them. Sometimes they will actually connect, creating a combination of the two. An entire book could be written on clouds and how to paint them, for their looks are endless. I am fascinated by them and could easily become obsessed, painting nothing but clouds. But I will control myself for the sake of this book, and focus on the most common ones instead.

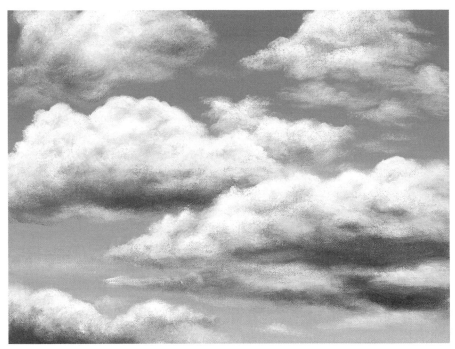

Cumulus Clouds

This is the type we usually think of first when referring to clouds. It is stereotyped by its white fluffy nature. These are the types of clouds we like to look at, trying to find the hidden shapes within them. They get their name from their distinct round shapes. *Cumulus* means "heap" in Latin.

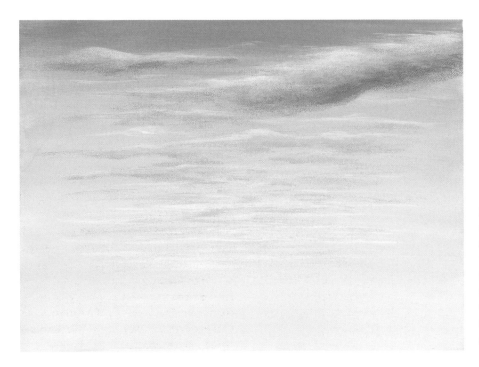

Cirrus Clouds

Cirrus clouds are recognized by the wispy look streaking across the sky. *Cirrus* in Latin means "wisp of hair." There are different types and formations of cirrus clouds, ranging from thin streaks to thick smears across the sky. When wind is high, their shapes can even take on a spiral shape. Sometimes they are referred to as a "Mare's Tails."

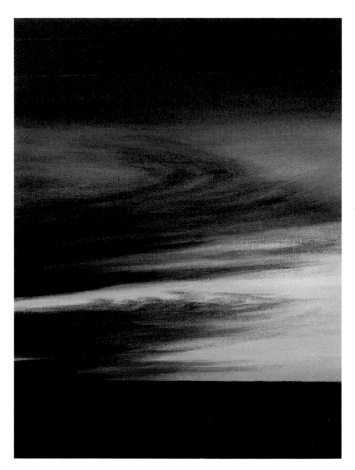

Stratus Clouds

These clouds are made up of horizontal layers in the atmosphere and often reflect beautiful colors from the sun. The name *stratus* means "layer" in Latin. These clouds are found in the lowest layers of the atmosphere and often will be seen along with other cloud formations. Often you will see what is called a stratocumulus cloud formation, where two cloud layers merge together.

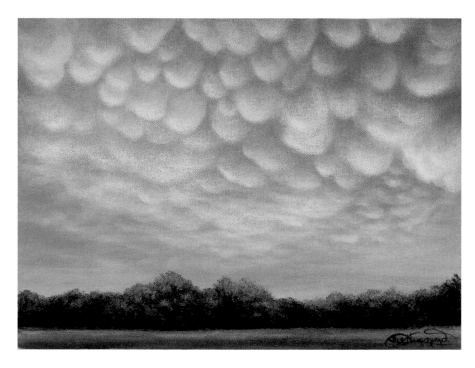

Mammatus Clouds

Their Latin name comes from the word *mamma*, which means "breast." Their formation is named for the similarities in their lumpy structures. They are known for their repetitive round shapes that resemble a collection of cotton balls. They have one of the most distinctive patterns found in clouds, making them good for interesting art.

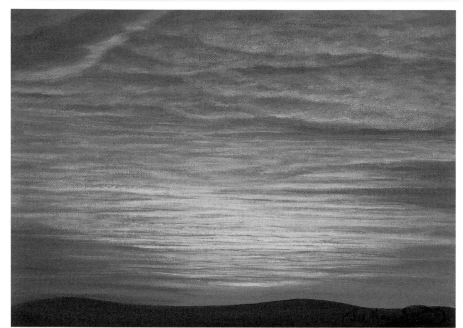

Altostratus Clouds

These create multiple layers and streaks throughout the sky, creating a blanketlike impression. As you can see from this example, the colors they reflect can be quite beautiful.

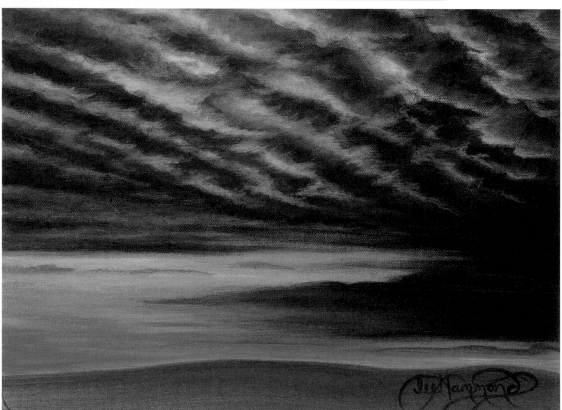

Altocumulus Clouds

Altocumulus clouds are beautiful cloud formations that create bands and patterns that stretch across the sky. They are similar to the alto-stratus above, but they often will produce more angular patterns than the straight, horizontal formations seen with the stratus clouds. Often these clouds can even be called a "Mackerel Sky" because the patterns come together to resemble the scales on a fish.

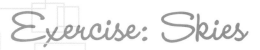

Exercise: Skies

Cirrus

Let's practice painting some cloud formations, starting with the easiest first—the cirrus clouds. As with any sky, the background color should be done first. It is important that this be done well, with the right consistency of paint. You don't want it to be too thin, as to look like watercolor. You also do not want it to be too thick because the speckles of the canvas will show through.

MATERIALS LIST

PAINTS
Prussian Blue and Titanium White

BRUSHES
1-inch (25mm) flat, no. 2 liner

CANVAS OR CANVAS PAPER
Any size

Prussian Blue

Prussian Blue is highly potent, so it requires very little to create sky blue. Just a slight touch of it will colorize a large puddle of white paint. Proceed with caution, or you will end up with way more paint than you need, having to add more and more white to tone it down.

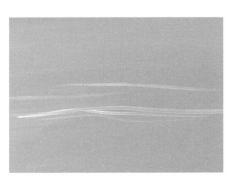

1 Basetones

With a 1-inch (25mm) flat, apply a smooth, even sky color with smooth horizontal strokes; use Titanium White with a tiny dab of Prussian Blue. Apply the paint smoothly and evenly. This stage must be complete before applying the clouds. Once the paint has dried, apply very thin wisps of pure white paint with a no. 2 liner. Use quick, light, horizontal strokes to keep them very thin and hairlike.

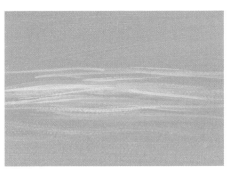

2 The Awkward Stage

Air masses move horizontally, and the look of your clouds must follow that direction. With the same no. 2 liner, apply more strokes of the wispy clouds with quick horizontal strokes to build up the cloud layers.

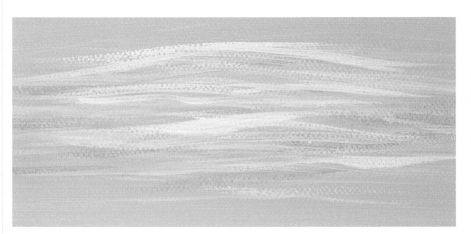

3 Finish

Add more layers to the clouds using the same types of strokes, layering them all together. Your strokes should vary in size to keep them from looking like stripes. Try this exercise once more using different colors. Look at the example on page 50, and try to paint those as well.

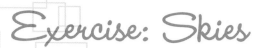

Stratus

Painting stratus clouds is very similar to the previous exercise. Cirrus clouds have the same characteristics, but stratus clouds are a bit heavier and more filled in. Follow along to create these pretty stratus formations.

MATERIALS LIST

PAINTS
Cadmium Yellow Medium, Cadmium Red Light, Dioxazine Purple and Titanium White

BRUSHES
1-inch (25mm) flat, no. 2 round sable or synthetic

CANVAS OR CANVAS PAPER
Any size

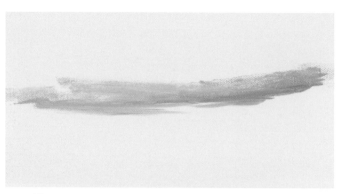

1 Basetones

Mix a pretty pale yellow using Cadmium Yellow Medium and Titanium White. Apply this to the entire sky area with a 1-inch flat (25mm), horizontal strokes and a smooth and even application.

When that layer is dry, begin the cloud formations using a no. 2 round sable or synthetic, quick horizontal strokes and a Dioxazine Purple and Titanium White mixture. Because yellow and violet are opposite colors, the violet appears grayed down.

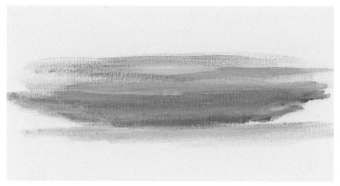

2 The Awkward Stage

Apply streaks of alternating colors.

With the same no. 2 round begin streaking horizontal strokes of a salmon color (Cadmium Red Light with a touch of white) into the lavender strokes already there. Add more lavender as needed for more volume.

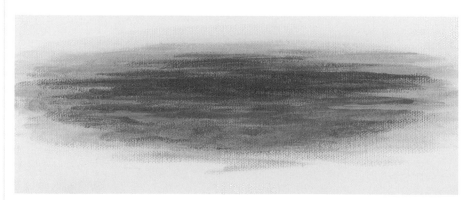

3 Finish

Build up layers of horizontal strokes for volume. Continue layering these colors with the same no. 2 round sable or synthetic, alternating the colors as you go to build up the look of layers.

Cumulus

Cumulus clouds are very full and fluffy. Usually their tops are very white, and their underbellies are a shade of gray. They can hang in the sky alone or be seen in large groups. You will see them in every size and shape. Higher-level clouds appear to be still to the eye, while cumulus clouds can be watched as they move silently across the horizon.

<div style="border:1px solid">

MATERIALS LIST

PAINTS
Ivory Black, Prussian Blue and Titanium White

BRUSHES
1-inch (25mm) flat, no. 4 filbert or flat

CANVAS OR CANVAS PAPER
Any size

</div>

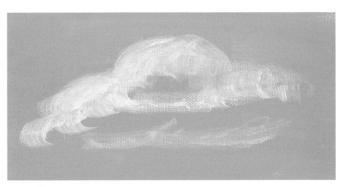

1 Basetones

With a 1-inch (25mm) flat, paint the entire sky light blue (white and a very small amount of Prussian Blue). Remember, Prussian Blue is extremely potent. Apply a smooth, even coverage of paint using horizontal strokes. Once this layer is completely dry, begin creating the fluffy shapes of the cumulus cloud with a no. 4 filbert, Titanium White and curved brushstrokes.

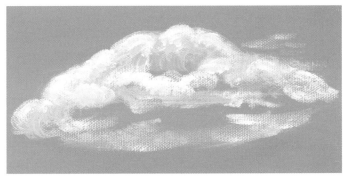

2 The Awkward Stage

With a no. 4 filbert and using the same curved stroke, build up the density of the paint to make the cloud even whiter and fluffier. Allow some sky blue to still peek through to make the cloud look airy and not too filled in.

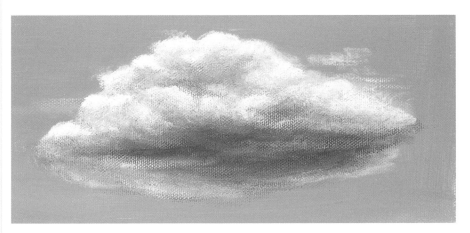

3 Finish

Mix a blue-gray by mixing a small touch of Ivory Black into Titanium White, then adding a tiny touch of Prussian Blue. Using a no. 4 filbert, add the dark shadow underbelly of the cloud. Vary the color, making some areas a bit lighter than others to keep it airy.

Silhouettes

Silhouettes are often seen in nature due to the lighting. *Backlighting,* where everything in the distance is illuminated, makes everything in the foreground appear colorless and dark. When painting landscapes, often the details of the scenery take second place to the sky. Many of the paintings I create are some form of silhouette, especially using trees. As pretty as the sky is, to finish many paintings, you'll want to know how to paint the shapes of trees. We will cover them in more detail later on, but for now, we will learn to paint trees in silhouette form. This will give you practice painting their shapes without having to concern yourself with color.

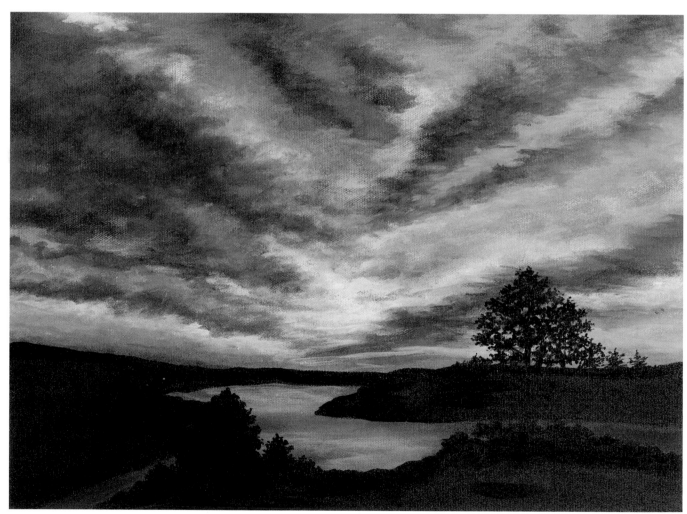

CLOUDS OVER THE RIVER
12" × 16" (30cm × 41cm)

Colors Used: Alizarin Crimson, Cadmium Red Light, Cadmium Yellow Medium, Dioxazine Purple, Ivory Black, Prussian Blue and Titanium White

Using Silhouettes

The exercises to come will help you practice painting different types of skies and silhouettes. Then you can create your own scenes using different types of trees. The sky is the limit to what you can come up with!

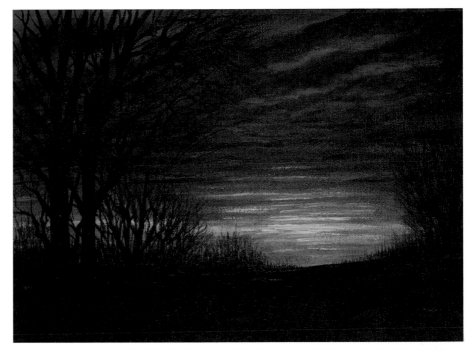

Daylight is almost gone in this scene, and the sun is already below the horizon. Without even seeing everything, we know that these are trees; they are recognizable shapes. With the trees varying so much in height, a lot of distance is created without even having to see the details, or what is going on between the trees. Even though everything appears black and filled in, the illusion of depth is still intact.

WILDERNESS SUNSET
12" × 9" (30cm × 23cm)

Colors Used: Alizarin Crimson, Cadmium Red Light, Cadmium Yellow Medium, Dioxazine Purple, Ivory Black, Prussian Blue and Titanium White

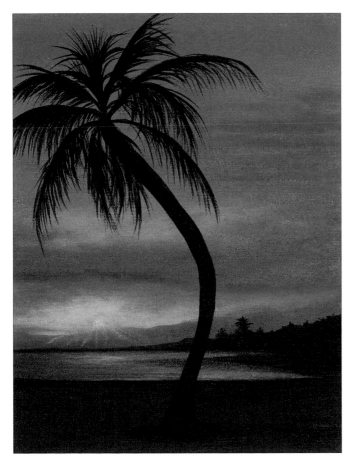

Sunsets create beautiful silhouettes. No two are ever the same. The warm and cool colors playing off one another and the way the palm tree silhouettes against the sky with its gently curved trunk is very calming. You can create this effect quite simply using a silhouette rather than a detailed tree.

PUERTO VALLARTA SUNSET
9" × 12" (23cm × 30cm)

Colors Used: Alizarin Crimson, Cadmium Red Light, Cadmium Yellow Medium, Dioxazine Purple, Ivory Black, Prussian Blue and Titanium White

Trees Basics

Here are some quick exercises to give you the basics for painting trees in silhouette form. It is all in the brushstrokes and observing the shapes. All trees start with a vertical line that represents the trunk. Everything builds off of that. Depending on the size and scale of your painting (larger paintings require larger brushes) paint in the trunk with the pulling motion and a round (thicker trunks) or liner (thinner trunks) brush. Add a bit of water to your paint to create an inklike consistency. It is important that when pulling the brush that the paint moves fluidly.

MATERIALS LIST

PAINTS
Ivory Black

BRUSHES
No. 2 liner, no. 2 round, no. 4 filbert

CANVAS OR CANVAS PAPER
Any size

Pine Tree

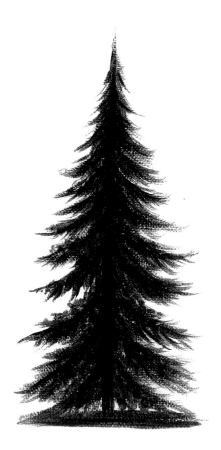

1 Start at the base with the no. 2 liner and pull upward so the line tapers, getting smaller as it goes up. Once you have painted in the vertical guideline that represents the trunk, observe the direction of the branches. Add the limbs in curved, downward-tapered strokes. This tree's branches tilt downward first, then flip up at the ends. Using the same brush, add the foundation for the branches.

2 Still using the liner and quick brushstrokes, slowly fill in the shapes of the branches. Remember that this is a silhouette; you will not see the details. Make the ends of the branches look wispy, not solid. It should look like there are pine needles sticking out.

Fir Tree

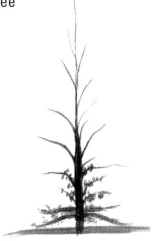

1 This tree is similar in shape to the pine, but it is not as filled in. Start with an upward pull to create a tapered vertical line. Once the trunk is created, add the limbs with curved, upward strokes.

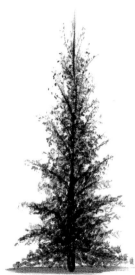

2 Use stippling (see page 29) to fill in. In some areas, the paint becomes worn off and goes on lighter, as in drybrushing. This keeps it looking natural. In these areas you can add some extra tiny lines to make the illusion of little limbs. If you get carried away, as I sometimes do, just mix some of the background color, and stipple back into the black, making it look open again.

Leafy Tree

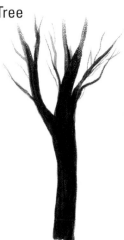

1 Pull upward with a vertical stroke and a no. 4 filbert for the trunk. Separate it into two large limbs. Use a round or liner to add branches off these with upward strokes. Allow the strokes to taper at the ends, getting smaller as they go up.

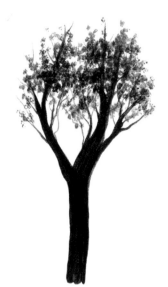

2 Fill in the foliage by dabbing with a no. 2 round. This is much like the stippling on the fir tree. The light and dark patterns of the clumps of leaves can make or break the look of the tree. Allow the light to come through in areas. If you do fill in too much, just mix more of the color behind the tree and carefully dot back in to open it up.

Palm Tree

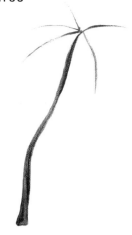

1 Tropical trees such as the palm have their leaves coming out the top of the trunk. Apply the trunk with the same upward stroke as before and a liner. With the liner or round brush and tapered strokes, create the thin center vein of the palm leaf.

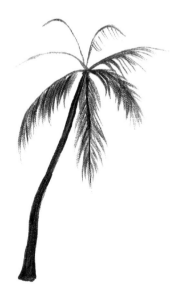

2 Add the thin lines coming off of the main vein to create the palm leaves. The leaf of the palm is made up of many thin lines all coming off of the main vein. Depending on the direction the leaf is facing, these small lines may seem to parallel one another or overlap. When they overlap, they seem to fill in.

Trees and Plants

The earth is filled with plants, trees and flowers, each of which gives artists endless subjects to capture. When painting them, it is not necessary to put in every small detail. Just a suggestion is all that is needed, especially for things in the distance. The farther away something is, the less detail you see. As with clouds, it is important to know your terrain, and only place a tree in your composition that would actually appear in that climate and type of scene. We have delved into the world of painting trees in silhouette form, now we'll learn how to paint them in full detail.

We must now learn how to create the illusion of realism in the details of trees, plants, flowers and grasses. There is much more to it than meets the eye!

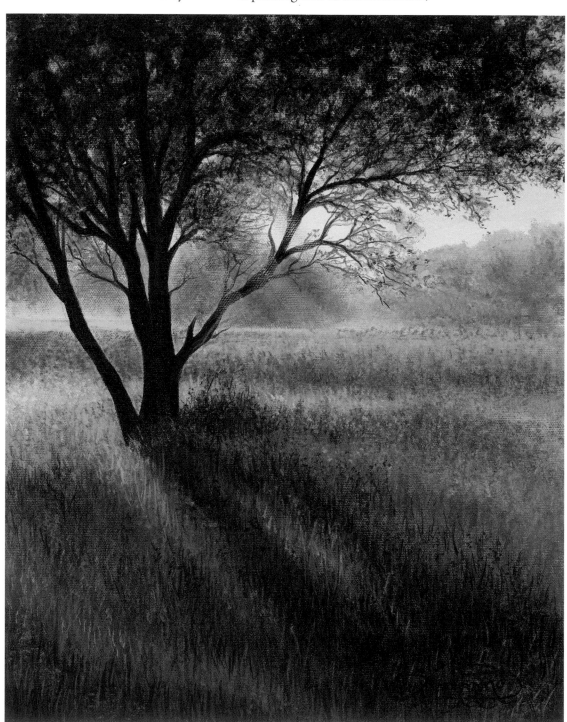

AUTUMN SHADOWS
16" × 12" (41cm × 30cm)

Colors Used: Alizarin Crimson, Burnt Umber, Cadmium Red Light, Cadmium Yellow Medium, Ivory Black, Prussian Blue and Titanium White

Types of Trees

Painting trees is fun, but as with clouds, there are different types, and it is important to know what type of tree it is that you are creating. We'll talk about two main types of trees, deciduous and coniferous (though there are many more variations and divisions).

The biggest problem I see my students have is creating what I call cookie-cutter limbs. Trees vary in the size and shapes of their branches. When painting, our brains seem to want to interfere and make everything even and overly symmetrical. Be observant as you paint, and try not to make everything look too perfect. Life isn't perfect! Allow the imperfections and oddities in nature to come through. It will make for better realism.

Deciduous Tree

This is the type of tree that has leaves, and it sheds those leaves annually in the fall. There are also the tropical trees, such as palm trees. All of these types of trees have very distinctive shapes, and to paint them well takes both a good understanding of their shapes and lots of practice!

Coniferous Tree

These are the types of trees that have needles. They keep their color and hold on to their needles all year long, and they look much the same year round. There are many types. Some are very full and resemble the tree we identify with Christmas. Some have very long needles and resemble shaggy dogs. Others are tall and lanky with more trunk than anything else.

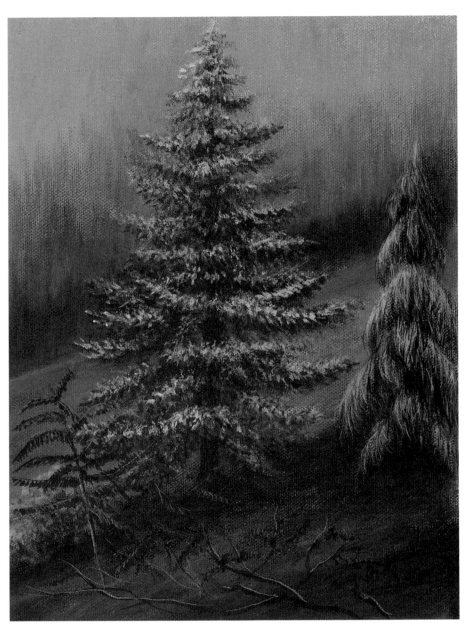

All Trees Are Different
There are divisions upon divisions of trees. Compare these two pine trees and you can see how different they are, though they are both coniferous trees. The larger one has branches that reach out to the side, lifting up at the ends. The smaller one hangs down with its branches looking droopy. Look into the background of this painting and you can see how the illusion of trees has been created with just a suggestion of shapes. This gives a look of distance by eliminating the details. This painting has a lot of elements to study. (The small red fernlike plants in the foreground are created with a liner brush.)

STUDY OF PINES
12" × 9" (30cm × 23cm)

Colors Used: Alizarin Crimson, Burnt Umber, Cadmium Red Light, Cadmium Yellow Medium, Ivory Black, Prussian Blue and Titanium White

Exercise: Trees and Plants
Foliage

Deciduous trees look very different from season to season. Through winter, they may have only branches. In the spring the leaves come back and stay full throughout the summer. The foliage fills in, hiding many of the small branches. You've had some practice creating tree branches. Let's practice filling them in a bit.

The grass had turned green, but the leaves hadn't formed yet. A deciduous tree loses its leaves every year. In the fall and winter, the branches are bare like this. The tiny branches and limbs are apparent.

EARLY SPRING
4" × 9" (10cm × 23cm)

Light

It is really light effects that make a painting great. When selecting your photo references, look for lighting situations that will create an interesting look. Don't settle for ordinary when lighting can provide you with spectacular!

Branches, Don't!
These lines are too thick and too much the same everywhere. It looks thick and contrived. These were painted with a no. 2 round, which is too large for delicate lines.

Branches, Do!
These tree limbs look much better. They were created with the no. 2 liner, which makes the lines taper at the ends. The varying sizes of the limbs makes this look much more realistic.

1 Medium Colors

Foliage is made up of light, medium and dark colors. (Refer to the color swatches on page 21 to see all the different colors of green.) Start with the medium colors first with a dabbing motion.

2 Darker Colors

Dab the darker color for the look of shadow effects and volume.

3 Lighter Colors

Dab on the lighter color for the look of light reflecting. Repeat the colors until you like the look. Sometimes it takes many layers to get it right!

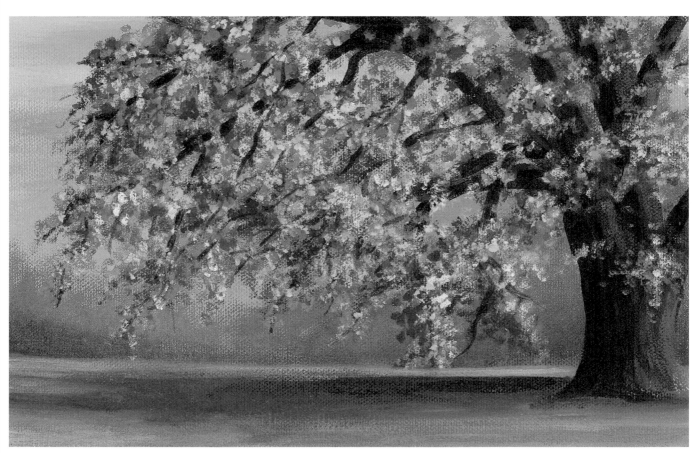

Compare this painting with the one on page 62. You can see that they are basically the same scene, but different times of year.

LATE SPRING
4" × 9" (10cm × 23cm)

Bark

Now let's try a simple approach to painting tree bark with this simple lesson.

MATERIALS LIST

PAINTS
Burnt Umber, Cadmium Red Light, Ivory Black and Titanium White

BRUSHES
No. 2 liner, no. 2 round bristle

CANVAS OR CANVAS PAPER
Any size

1 Medium Colors
Mix a small amount of white into Burnt Umber to create a medium brown. Apply it in the shape of a cylinder using a no. 2 round. Tree trunks and branches are made up of the long cylinder shape. Refer to page 37.

2 Dark Colors
Using a no. 2 round, mix a small amount of black into the Burnt Umber to make a very dark brown. Apply this with a drybrush application to create the shadow side of the trunk and to add the rough texture of the tree bark.

3 Light Colors
Add a small dab of Cadmium Red Light into the medium-brown base color, and add a bit of white to that to lighten. Add this color with a dry brush on the highlight side. Add more of the white to intensify the light source and to build up the look of texture.

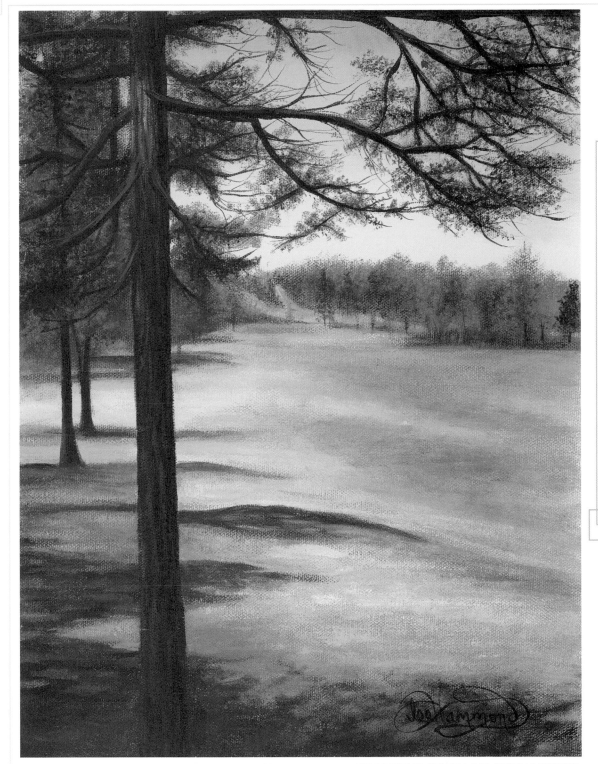

Shadows

Taller trees create beautiful shadows. Look for great shadow effects when looking for things to paint. Look at some of the small details of this painting. See how the light is coming from the left? This is what casts the great shadows.

Notice how the look of tree bark is created by drybrushing.

MY BACKYARD AT TEGA CAY, SOUTH CAROLINA
12" × 9" (30cm × 23cm)

Colors Used: Alizarin Crimson, Burnt Umber, Cadmium Red Light, Cadmium Yellow Medium, Ivory Black, Prussian Blue and Titanium White

Exercise: Trees and Plants
Birch Tree

I love the look of the birch trees standing out against the darker colors of a wooded area. It doesn't matter what the season, they seem to stand out against everything else. They are really just long cylinders or tubes. The secret to creating believable birch trees is all in the bark.

MATERIALS LIST

PAINTS
Burnt Umber, Cadmium Red Light, Cadmium Yellow Medium, Ivory Black and Titanium White

BRUSHES
No. 2 liner, no. 2 round bristle, no. 4 flat

CANVAS OR CANVAS PAPER
Any size

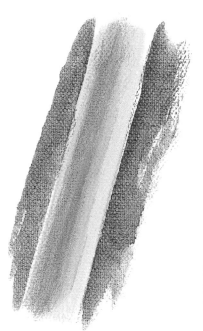

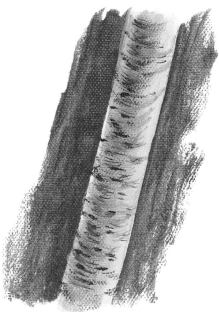

1 Basecoat
With a no. 2 round bristle, base in the tree trunk with white.

2 Earth Tones
Since the tree trunks are light, you must have some color around them. Scrub in some earth tones as shown with a no. 4 flat brush. Use Burnt Umber, Cadmium Red Light, Cadmium Yellow Medium.

3 Finish
Create a warm gray mixture with white, black and a touch of Cadmium Red Light. Create the shadow edge as shown. Add the black surface details with a small liner brush.

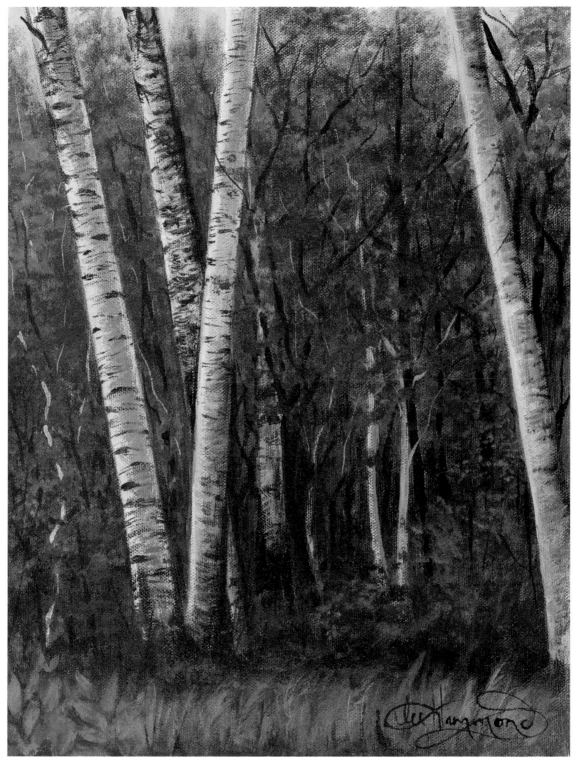

You can see how I used the five elements of shading to create these trees. The sides have a lot of reflected light running down them, and the roundness is created by the shadow edge going down the midsection.

AUTUMN BIRCHES
12" × 9" (30cm × 23cm)

Colors Used: Alizarin Crimson, Burnt Umber, Cadmium Red Light, Cadmium Yellow Medium, Ivory Black, Prussian Blue and Titanium White

Exercise: Trees and Plants
Spruce

Let's try a quick study of a spruce tree before moving on. This tree is simple in both its shape and color.

MATERIALS LIST

PAINTS
Cadmium Yellow Medium, Ivory Black, Prussian Blue and Titanium White

BRUSHES
No. 2 liner, no. 2 round bristle

CANVAS OR CANVAS PAPER
Any size

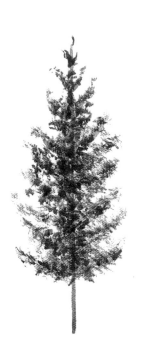

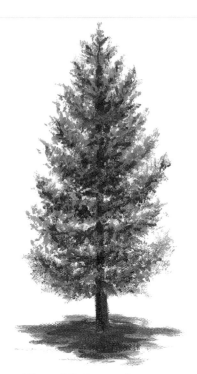

1 Trunks and Limbs
With a no. 2 liner and Ivory Black that has been thinned down with a little water, pull up the strokes for the trunk and limbs as shown.

2 Foliage
With a no. 2 round bristle, lightly dab the black into the tree to start the look of foliage. Use your paint thicker for this application.

3 Hint of Color and Shadow Below
Mix a blue-green for the tree's hint of color. Add a small amount of Prussian Blue into some white. Then add a small amount of Cadmium Yellow Medium into that. Add more white if necessary to create the pastel tint. Using the same no. 2 round bristle, lightly dab this color on top of the black already applied. If it gets too heavy, simply add some more black mixture into it to open it up. Create a very light tint of the blue-green color by adding more white, and apply a small amount on the tips of the branches for a soft look. Add the shadow underneath for a realistic look.

Grass and Flowers

In landscape painting, adding flowers is about creating the illusion of flowers, rather than single flowers in great detail. Stay loose while you paint. If you get too caught up in the small details, trying to put in more than you need, you may end up with a very cartoonlike outcome.

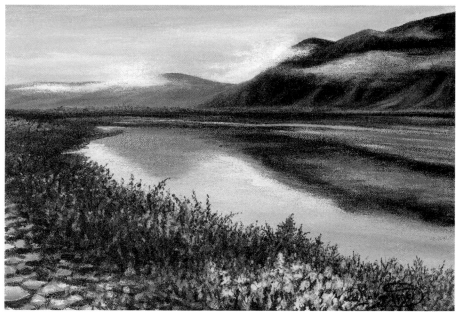

Flowers in a Landscape

Flowers in a landscape are generally seen at a distance, meaning you won't need to paint them in great detail. This painting suggests a lot of flowers along the lake. They were created using the dabbing technique with many layers of colors.

FLORAL SHORES
9" × 12" (23cm × 30cm)

Colors Used: Alizarin Crimson, Burnt Umber, Cadmium Red Light, Cadmium Yellow Medium, Dioxazine Purple, Ivory Black, Prussian Blue and Titanium White

Flowers in a Bush

Allow the flowers to look like separate clumps and separate branches. You don't want a big pink blob. If it does fill in too much, let it dry, and reapply some of the greens to open it back up.

1 Once the main color of the bush has been scrubbed in using the dark shades of green, mix a deep pink with Alizarin Crimson and Titanium White. With a no. 2 round sable or synthetic, dab small controlled dots of color over the green. Use a light touch to make more distinct shapes.

2 Continue to dot in flowers using different shades of pink with many layers and varying shades. Alternate from pure Alizarin Crimson to pale pink made by adding a lot of white. With a liner and black, create the small limbs going in and out of the flowers. Use a stippling approach to creating the flowers.

Rocks and Mountains

One of artists' favorite landscape elements is the glory of a mountain range. Some artists, such as Paul Cézanne, created hundreds of paintings of the very same peaks. Because of the lighting and weather, the same subject can look a thousand different ways. Mountains never disappoint in the opportunities they can present to an artist. There are many different types of mountains. Some are tall and rocky with jagged ledges and an extremely chiseled appearance. Some are smooth with greenery adorning their shapes, while others seem barren, like huge piles of dirt! Mountains are not difficult to paint. I think that is because they are so defined, and the light source is always clearly visible. It is the smooth subtle objects that are hard to depict well.

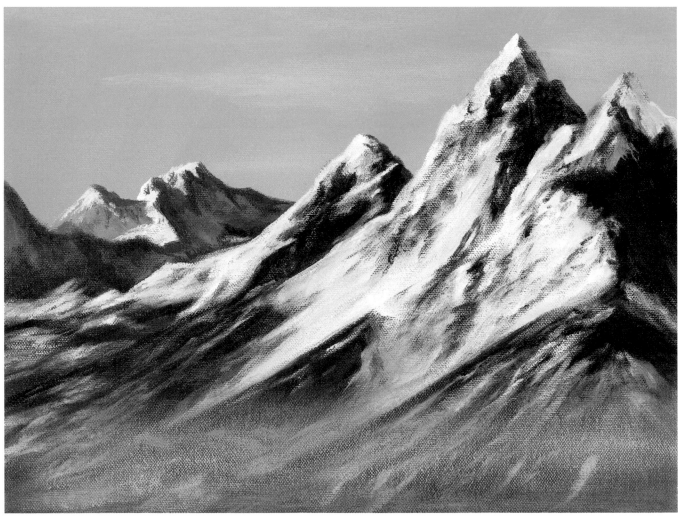

ROCKY PEAKS
9" × 12" (23cm × 30cm)

Colors Used: Ivory Black, Prussian Blue and Titanium White

Exercise: Rocks and Mountains
Peaks

Follow along to paint the peaks!

MATERIALS LIST

PAINTS
Dioxazine Purple, Ivory Black, Prussian Blue and Titanium White

BRUSHES
1-inch (25mm) flat, no. 2 round bristle, no. 2 round sable or synthetic

CANVAS OR CANVAS PAPER
Any size, but 9" × 12" (23cm × 30cm) was used for this piece

1 Begin with the sky color. Create the shapes of the mountain peaks with black. Fill in the shadows on the right. Paint the sky area with the standard sky blue color, created with Titanium White and Prussian Blue. Use the 1-inch (25mm) flat for this. With a no. 2 round sable or synthetic, carefully paint in the shapes of the peaks with pure black. Notice how the light is coming strongly from the left, and all of the cast shadows are on the right. Create a blue-gray color by taking white and adding a small amount of Prussian Blue and a dab of black. Using the no. 2 round, add the shadow to the right side of the mountain peak on the left.

2 Add the snow to the peaks, and then drybrush the pastel colors for realism. Use the no. 2 round sable or synthetic and add pure white to the light areas of the mountains. Allow the edges of the white to become a dry brush effect as it meets the black. Add a tiny bit of Prussian Blue to the white and drybrush this over the white in some areas. Be sure the white is completely dry first. Use a no. 2 round bristle for this. Add a touch of Dioxazine Purple to the light blue mixture, and add the lavender to the peaks on the left. Again, allow this to be somewhat drybrushed on. Once you have mastered this, you can create the painting on the previous page. Make this painting as large as you'd like. Just adjust the size of your brushes accordingly.

Rocks

It isn't always necessary to show an entire scene when it comes to landscape painting. Closing in on a certain element can often tell a good story or create an interesting look. Rocks can create wonderful compositions. All their many surfaces and shapes reflect light and color beautifully. While it is a bit of a challenge and can become time consuming addressing each one, the outcome is well worth the effort! We will now learn to see the small details instead of the large masses and paint individual rocks. It really is all about the light source bouncing off the surfaces of each rock and illuminating the shapes and angles of each rocky formation. Follow along!

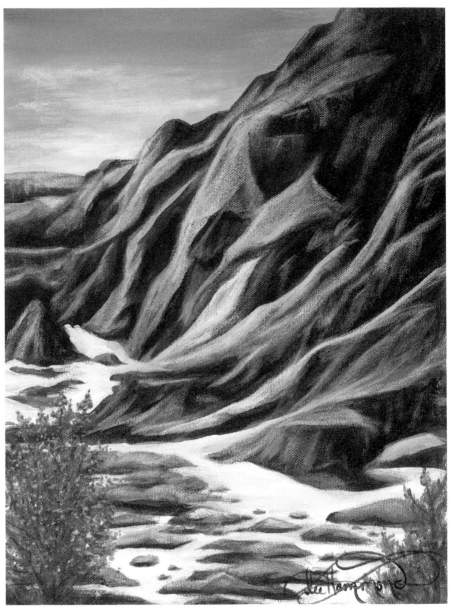

THE ROCKS OF LAKE TAHOE
12" × 9" (30cm × 23cm)

Colors Used: Burnt Umber, Cadmium Yellow Medium, Ivory Black, Prussian Blue and Titanium White

Rocks

Before we can attempt to paint a rocky scene, we must first have some practice painting rocks in general. This small exercise will show you what to look for and how to create a realistic-looking rock or stone.

MATERIALS LIST

PAINTS
Burnt Umber, Cadmium Red Light, Ivory Black and Titanium White

BRUSHES
No. 2 flat, no. 2 round sable or synthetic

CANVAS OR CANVAS PAPER
Any size

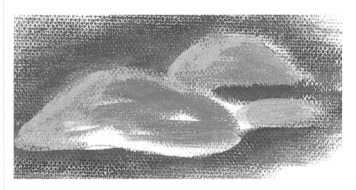

1 Basecoat

Using a no. 2 round, lightly sketch in the basic shapes. Mix a small amount of Burnt Umber into some Titanium White, then add a touch of Cadmium Red Light for a light brown and paint around the shapes. Add a touch of Cadmium Red Light to some white for a peachy color, and base in the rocks. Add a small amount of Ivory Black to the light brown color, and add this under and around the rocks for contrast.

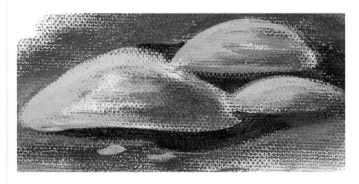

2 The Awkward Stage

The rocks resemble the sphere exercise (pages 33–35). With a no. 2 round sable or synthetic, paint in the shadows behind and beneath the rocks with pure Burnt Umber. Drybrush some of this color onto the right side of the rocks, too. Leave a light edge along the bottom to represent the reflected light.

Mix a tiny bit of Burnt Umber into Titanium White for a warm light gray. Use the no. 2 round to apply this on the left side of the rocks where the light is hitting them. Add a few smaller stray rocks around the large ones. Add some Ivory Black to the Burnt Umber and deepen the cast shadows under the rock.

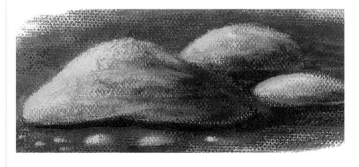

3 Finish

Use a no. 2 flat to drybrush darker values into the shadow sides using Burnt Umber. Drybrush Titanium White into the full light areas for highlight. Deepen the color of the ground by drybrushing with Burnt Umber. Make the little rocks stand out more by adding Titanium White to them.

Painting Water

Water is a constant in nature. There are just a few simple rules to making water look realistic.

- Remember that water is highly reflective. Any colors above or around it show up in the water. Water is not always blue. It is only blue if the sky is blue and reflecting down into it.

- Water is a moving surface. The surface can range from smooth to immensely rough. The surface moves horizontally much like the atmosphere.

- You can create water with light, medium and dark tones, like anything else.

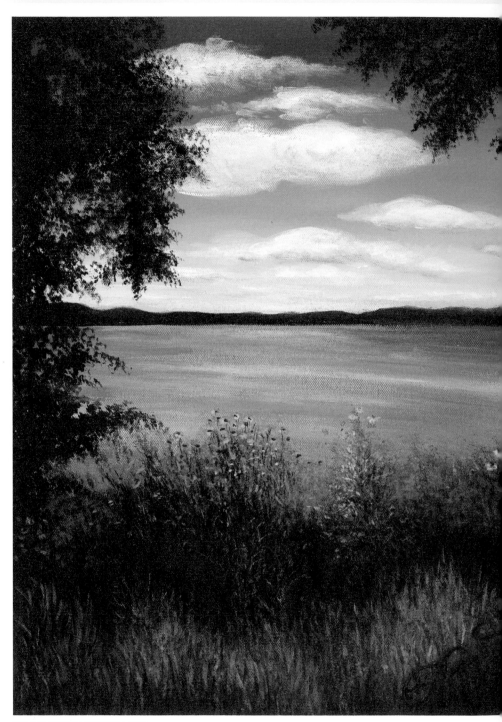

WILDFLOWERS ON THE LAKE
16" × 12" (41cm × 30cm)

Colors Used: Alizarin Crimson, Cadmium Red Light, Cadmium Yellow Medium, Ivory Black, Prussian Blue and Titanium White
From a photo by Pat Thomson

Exercise: Water

Light and Dark

The look of water depends largely on what the light is doing in the scene.

Water in Bright Light

1 Basecoat

With a 1-inch (25mm) flat, base an area in with light blue (Titanium White with a touch of Prussian Blue). Apply this loosely with horizontal strokes. You can see the streaks, and this is fine.

2 The Awkward Stage

With a deeper shade of the same blue, continue adding streaks horizontally going from the top downward. Use the same flat. You can see the feel of the water now being developed. Start the streaks with darker blue.

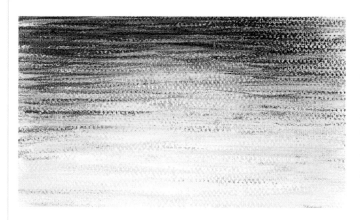

3 Finish

Complete this with a bit more control. Using a no. 2 liner, carefully add the tiny horizontal streaks over the other layers. Use pure Prussian Blue at the top and work down towards the center. When you get to the halfway point, switch to Titanium White and continue the process. Go back and forth with the dark blue and white until it looks like mine. Add the white streaks for reflections.

Darker Water

This second exercise is done the same way, but has a very different look. This water is much darker, with less light reflecting off the surface. The movement of the water is more evident and represents a body of water with waves.

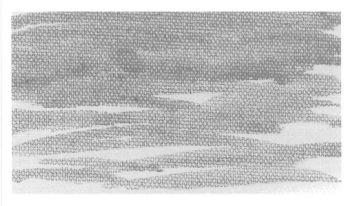

1 Basecoat

With a 1-inch (25mm) flat, loosely base an area in with light blue (Titanium White with a touch of Prussian Blue) with horizontal strokes. Create a darker version of the blue and apply it with sweeping horizontal strokes.

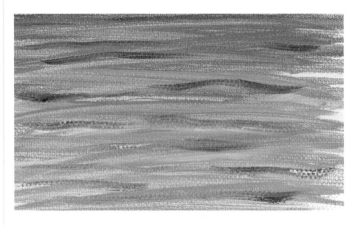

2 The Awkward Stage

Continue streaking the darker blue color with loose sweeping strokes. Add a small amount of Ivory Black to the Prussian Blue and add it to the top area of the water. Continue adding wavy streaks to create movement.

3 Finish

Switch to a no. 2 round sable or synthetic and continue adding the streaks with the dark blue mixture. Use wavy lines to represent the wave movement. Create a lighter blue by adding some Titanium White to the dark blue mixture, and add the lighter waves with the same wavy lines. Deepen the tones with dark blue and add the lighter waves.

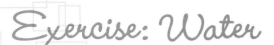

Exercise: Water
Reflections

We learned previously that the water is highly reflective, and it can create mirror images. This small project will give you practice creating a mirror image. After you complete this, go to page 44 and try that mountain painting too. Everything you need to complete it is in this exercise.

MATERIALS LIST

PAINTS
Dioxazine Purple, Ivory Black, Prussian Blue and Titanium White

BRUSHES
1-inch (25mm) flat, no. 2 round sable or synthetic

CANVAS OR CANVAS PAPER
Any size

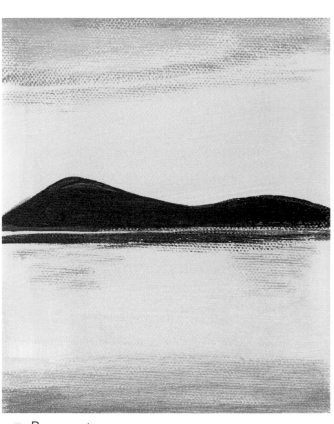

1 Basecoat

Base in the entire canvas with a layer of the sky blue mixture (Prussian Blue and Titanium White) with a 1-inch (25mm) flat. With Ivory Black and a no. 2 round sable or synthetic, fill in the mountain range. Move down to the water and start the mirror image of the mountain. Allow a small line of blue to separate the mountain from the water. Create a violet-blue by adding some Dioxazine Purple to the sky blue mix. Apply it with the same brush to the upper part of the sky. Repeat this color along the bottom of the water. Apply a small amount of this below the mountains as a guide to the reflections in the next step.

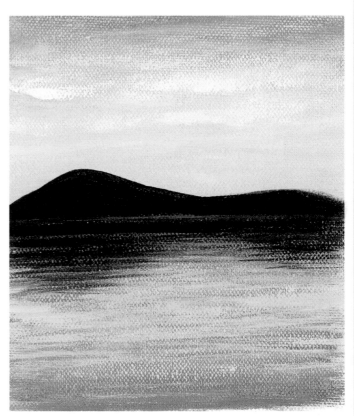

2 Finish

Streak some lavender (Titanium White and a small amount of Dioxazine Purple) clouds into the sky with horizontal strokes. Add some pure white clouds over the lavender ones. Keep it simple. Use the no. 2 round to add the clouds, allowing them to fade as they near the horizon line. Move down to the water and streak some of the lavender into the water with horizontal strokes. Use the same round for this. Create the reflection of the mountain with Ivory Black and horizontal strokes. Streak the lighter colors over it to make the reflections.

6

Putting It All Together

In this chapter, we'll combine the lessons learned to create beautiful, finished landcape paintings. You can do it!

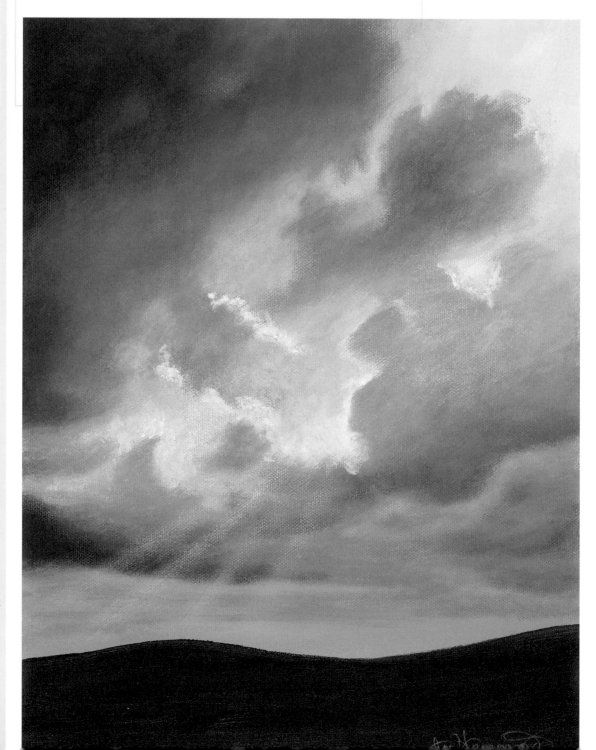

BLUE RAYS
12" × 9" (30cm × 23cm)

Colors Used: Cadmium Red Light, Cadmium Yellow Medium, Ivory Black, Prussian Blue and Titanium White

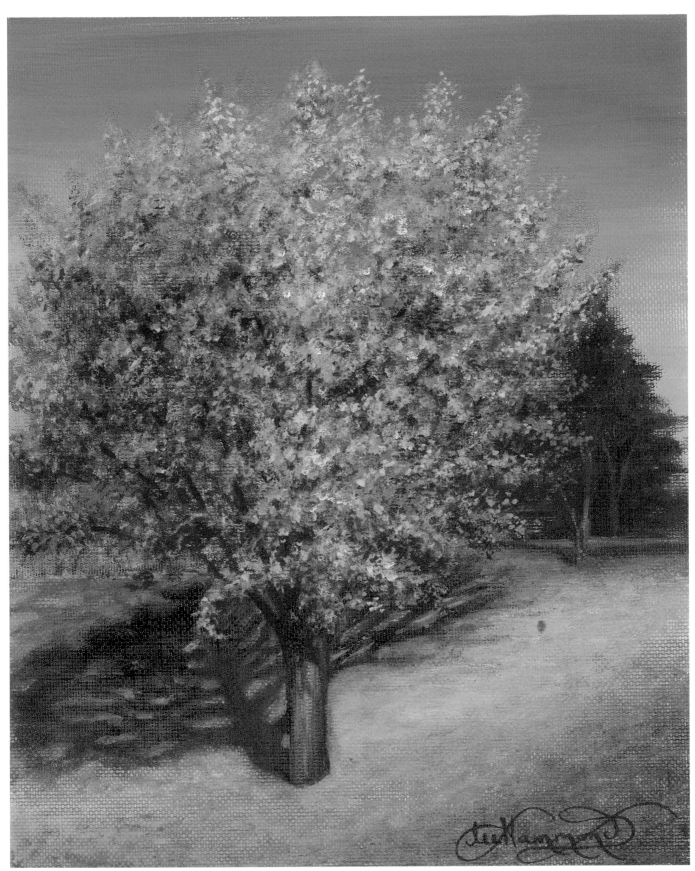

GOLDEN TREE SCENE
10" × 8" (25cm × 20cm)

Colors Used: Cadmium Yellow Medium, Burnt
Umber, Prussian Blue, Cadmium Red Light, Ivory
Black, Titanium White

Sunset

Clouds can take on endless combinations of shapes and colors. This project will give you practice creating a mood-provoking sunset. (Make this painting as small or as large as you'd like, for it will make quite a statement at any size). Refer to pages 50–55 for practice with clouds.

MATERIALS LIST

PAINTS
Alizarin Crimson, Cadmium Red Light, Cadmium Yellow Medium, Dioxazine Purple, Ivory Black, Prussian Blue and Titanium White

BRUSHES
1-inch (25mm) flat, no. 2 flat bristle, no. 4 flat bristle, no. 4 filbert, no. 2 round sable or synthetic

CANVAS OR CANVAS PAPER
11" × 14" (28cm × 36cm) or your choice

OTHER
Mechanical pencil

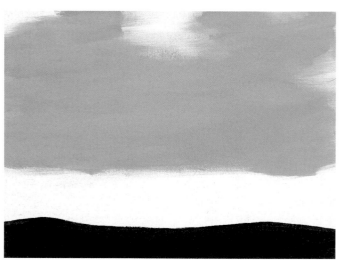

1 Basetones

Draw in the horizon line with a pencil. This one is very low in the picture plane. This will tell you where the sky ends and the ground begins. Then fill in the entire sky with sky blue (Titanium White and a touch of Prussian Blue) using a 1-inch (25mm) flat so it fills in at least three quarters of the sky area. This is the foundation we will need to build the clouds on top of. With black, fill in the area below the horizon line.

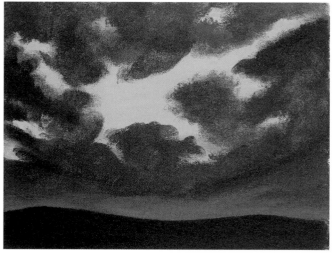

2 The Awkward Stage

This stage can look a bit sloppy, but it is very necessary. Here you work out shapes and colors, create the composition, and set the foundations for the final details. With Titanium White, Alizarin Crimson and a small touch of Prussian Blue, create a deep violet. With a no. 4 filbert or flat and a circular, scrubbing motion, build the basic shapes of the cloud formations to create the compositional balance. With Cadmium Yellow Medium and a bit of Titanium White, create a bright yellow and apply this to the sunshine area directly above the black area along the bottom to make the sun look like it is setting below the horizon. Add some Cadmium Red Light to the yellow and streak it along the horizon line to create the look of stratus clouds on the horizon.

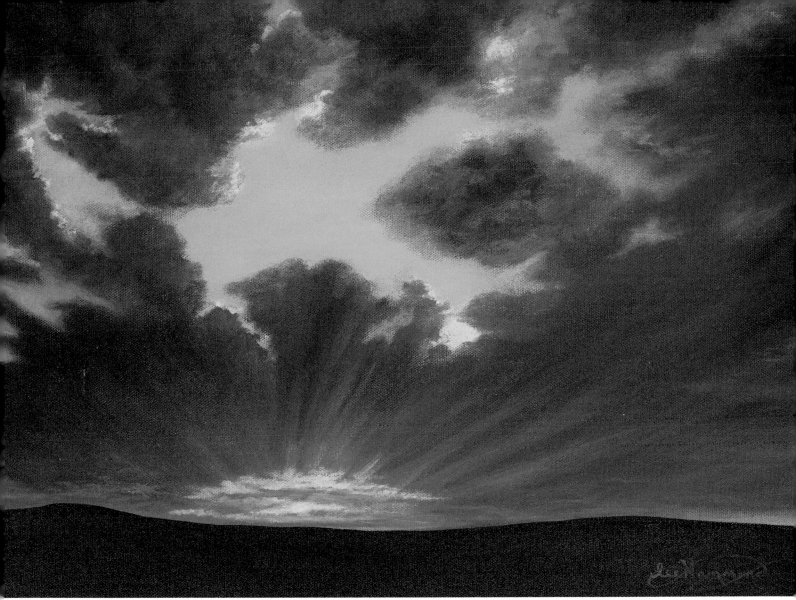

3 Finish

Gradually swirl in subtle colors on top of the shapes you painted in before using a no. 2 flat bristle, and mixing a wide variety of colors as you go. It is not necessary to mix separate puddles of paint. Just alter the paint on your palette as you work, changing colors slightly by adding tiny amounts of paint. Use variations made of Cadmium Red Light, Alizarin Crimson, Cadmium Yellow Medium and Dioxazine Purple, and circular, scrubbing motions to drybrush these colors into the clouds, making them fluffy.

For the silver linings, the light color along many of the edges, use a no. 2 round and a mixture of white and a bit of Cadmium Red Light. Some areas are whiter than others. Make sure that the edges vary. Allow them to soften out at the edges and be thinner or thicker in areas.

For the sun rays, mix a light orange with Cadmium Red Light, Cadmium Yellow Medium and Titanium White. Start in the center, and use a no. 4 flat bristle to drybrush the paint outward with long, quick strokes. Allow the paint to streak and fade at the ends of the strokes. It should look light and airy. Keep them straight, and allow all of them to originate from the same point on the horizon so they look uniform and straight like the spokes on a wheel.

SILVER LININGS
11" × 14" (28cm × 36cm)

Cloudy Sky

This is a brilliant silhouette, yet it is fairly simple to paint. The warm colors are a combination of yellow, orange and red. Because of the vivid colors, the silhouetted trees almost seem to glow in the foreground. Follow along to create this wonderful scene. Refer to pages 58–68 for the basics of painting tree shapes.

MATERIALS LIST

PAINTS
Alizarin Crimson, Cadmium Red Light, Cadmium Yellow Medium, Ivory Black and Titanium White

BRUSHES
1-inch (25mm) flat, nos. 1 and 2 liner, no. 2 flat bristle, no. 2 round sable or synthetic

CANVAS OR CANVAS PAPER
12" × 16" (30cm × 41cm)

OTHER
Mechanical pencil

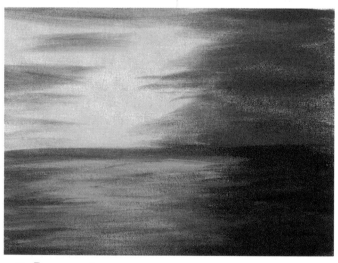

1 Basecoat

With a pencil, draw the horizon line slightly below the center point of the canvas. This divides the background from the foreground. With a 1-inch (25mm) flat and with wide and sweeping horizontal strokes, apply a layer of Cadmium Yellow Medium across the sky and water areas. Add a small amount of Cadmium Red Light to the Yellow to create a nice orange color. Using the same brush, add the orange mixture with the same type of brushstrokes. This will create the look of cirrus and stratus clouds and water texture. This must be done before adding the trees. Add a small amount of Alizarin Crimson to the Cadmium Red Light to make a vivid red color. Add this to the water area on the right side.

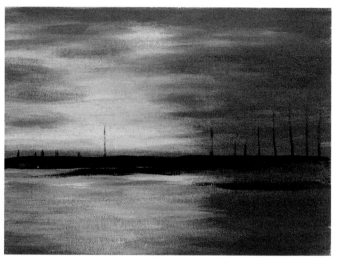

2 The Awkward Stage

With Ivory Black, add the ground in the horizon. With a no. 2 liner, add the vertical strokes that represent the tree trunks. As you can see, the reflections in the water have not yet been addressed. This is because they must be mirror images of the trees. We don't know what they will look like yet, so the trees must be done first. The trees and reflections in your painting may not look like mine, so adjust accordingly.

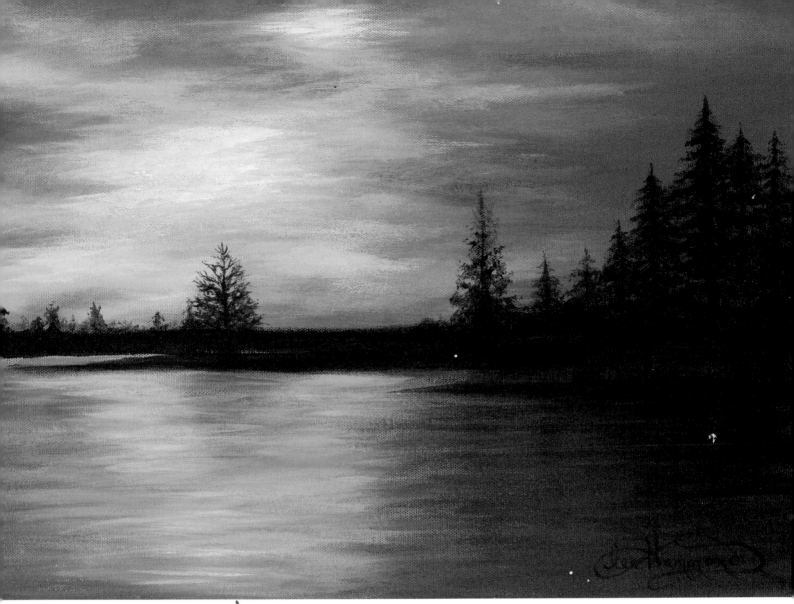

3 Finish

For the trees, we are merely creating an illusion with not much detail, just as in the exercises on pages 58–59. Dab in the shapes of the trees with a no. 2 round, looking at them as abstract shapes. Do not get caught up in what you know the details would look like. Shut off your "thinking" and proceed with artistic freedom. Dilute the black paint a bit to keep it from building up and appearing too heavy and to allow the colors of the sky to peek through. The tree just to the left of center is made up of small lines that represent limbs. Do this with a no.1 liner. Use a very light touch and quick flicks of the wrist, allowing the lines to taper at the ends for a wispy look. Do a small amount of dabbing with the liner brush towards the bottom to make it look full. With a no. 2 flat bristle, create the reflections of the trees on the right side. Just a representation is fine. Use horizontal strokes, once again keeping the paint a bit thin so it looks more transparent. Mix some white into the Cadmium Yellow Medium and add a few lighter cloud streaks to the sky. Add some of them to the water as well for sparkle.

GOLDEN GLOW
12" × 16" (30cm × 41cm)

Blended Colors

This is a fun project that will give you practice blending colors. Follow along to create this study of primary colors (red, blue and yellow).

The project on page 82 had a streaky, cloudy sky. This project is an example of a graduated color scheme, where the colors are very smooth and blended together. Working with blended colors can be more difficult because of the tendency for acrylic paint to dry so quickly. To create an even blend of color, mix larger amounts of paint, keeping it very fluid and moist as you work. It is a fine balance of paint and water because you do not want it to look transparent and streaky. Practice creating the blends (see pages 25–26) before you begin. And practice creating the trees (see pages 58–59). If you are not confident painting the tree shapes yet, take the time to practice on a separate sheet of canvas paper.

MATERIALS LIST

PAINTS
Alizarin Crimson, Cadmium Red Light, Cadmium Yellow Medium, Ivory Black, Prussian Blue and Titanium White

BRUSHES
1-inch (25mm) flat, no. 2 flat bristle, no. 2 liner, no. 2 round sable or synthetic

CANVAS OR CANVAS PAPER
16" × 20" (41cm × 51cm)

OTHER
Rag (optional)

1 Basecoat

Keep the paint moist and fluid throughout this step. Use a flat brush and sweeping horizontal strokes to blend the colors. Use a flat big enough to cover the size of your canvas. For a smaller painting, a 1-inch (25mm) flat will do. For larger paintings, you may want to use a 1½-inch (38mm) or a 2-inch (51mm) flat.

Mix a dab of Prussian Blue into a sizable blob of white to create a medium blue. Apply the paint from side to side, making sure it is smooth and even. With the paint still wet, add a small amount of white into the blue mixture and work down. Blend back and forth until the colors fade into one another for a gradual blend.

While the blue is drying, mix some white into a puddle of Cadmium Yellow Medium. Overlap the blue mixture. If your paint is still wet, it will create a green look as seen here. Ignore that for now and continue to work down.

Add some Cadmium Red Light into the yellow mixture and continue to blend this into the sky, allowing the orange and the yellows to merge.

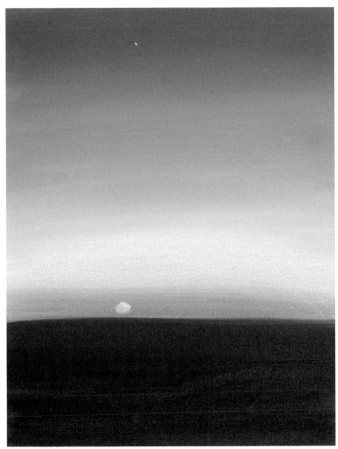

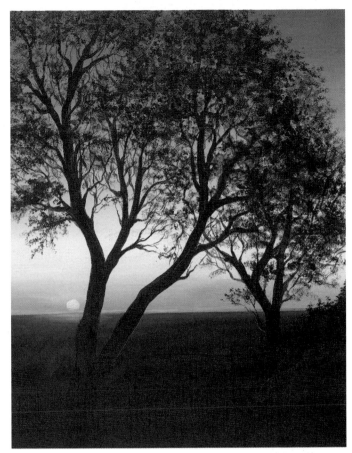

2 The Awkward Stage

Continue to blend the colors until they are smooth and gradual. Add Cadmium Red Light below the yellow. Once the paint has dried, use the Cadmium Yellow Medium and white mixture from Step 1 to drybrush over the greenish area we made between the blue and the yellow to soften it.

With Cadmium Red Light, paint in the area below the orange. These colors remain distinct and not blended. Add a small amount of Alizarin Crimson to this, allowing the red to become darker towards the bottom. With Ivory Black, fill in the foreground, creating a slight hill shape against the red. With a small amount of pure white, add the little circle into the orange area to create the setting sun.

3 Finish

Paint vertical strokes for the trunks with a no. 2 round sable or synthetic. Each tree is at a different distance, with the one on the left being closest to you. As they recede, they become smaller and shorter. Make sure that the trunks are different heights and thicknesses.

Use pages 62–68 as a guide to create two tree types using black to paint them in. The tiny ones on the far right are like pines (see page 68). The ones in the middle are leafy trees (see pages 62–63). Use the no. 2 liner to create the small tapered lines of the delicate tree limbs.

Next, drybrush in the sun rays using a no. 2 flat and a small amount of Cadmium Red Light. Wipe some of the paint off on your palette or a rag before you begin if you need to. With strokes that radiate outward like spokes on a wheel, drag the color down and over the darker colors below and across the trunks of the main trees.

A STUDY OF PRIMARY COLORS
20" × 16" (51cm × 41cm)

Winter Landscape

You can create a beautiful winter landscape by just combining what you know about painting skies and trees. This is where it starts to be fun! Follow along.

MATERIALS LIST

PAINTS
Burnt Umber, Cadmium Red Light, Cadmium Yellow Medium, Ivory Black, Prussian Blue and Titanium White

BRUSHES
1-inch (25mm) flat, no. 2 flat bristle, no. 2 liner, no. 2 round sable or synthetic

CANVAS OR CANVAS PAPER
9" × 12" (23cm × 30cm)

OTHER
Mechanical pencil

1 Basecoat

Always work from back to front. Pencil in the horizon line. This one is a bit below center.

The Sky

Winter skies are often monochromatic. This one is just a mixture of white with a small touch of Prussian Blue. Apply it with a 1-inch (25mm) flat and sweeping horizontal strokes. It's OK if it streaks; it becomes the look of the sky. Create the tree row.

The Foreground

Mix a medium earth color using Burnt Umber and white with a touch of Cadmium Red Light for warmth. Apply it to the foreground using the same brush and application as for the sky. Streaking is still OK.

The Tree Row

With a thicker application of paint and a dry-brush technique, scrub in the tree row at the horizon line using a no. 2 flat bristle. The trees are darker towards the bottom and irregular in shape.

2 The Awkward Stage

Build up the colors of the tree row and the foreground with drybrushing. Create the trunks and branches of the trees.

The Tree Row

Continue building up the tree row at the horizon line using a no. 2 flat bristle. Mix a deep green with Cadmium Yellow Medium and a touch of black. Add a tiny amount of Prussian Blue for a deep olive green, and scrub it into the right side of the row.

The Foreground

Move to the bottom of the canvas and add the deep olive green for a shadow effect. Use the same scrubbing technique as for the tree row.

The Main Trees

With Burnt Umber and a no. 2 round sable or synthetic, paint in the trunks and branches of the trees. Make sure the paint is fluid enough to pull up with the brush and create a tapered line.

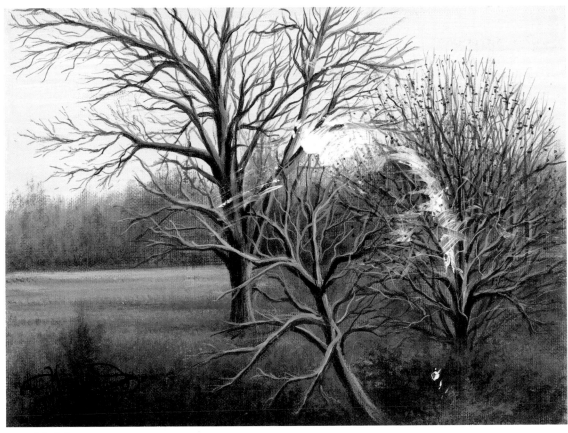

WINTER FIELDS
9" × 12" (23cm × 30cm)

3 Finish

You may work and rework areas until you really like them. Before you go crazy on the trees, make sure you are happy with the background and foreground.

The Foreground

Finish the ground with layers of colors. There is more texture visible in the front. The lighter colors in the background seem to run together. To create the lighter yellow-ochre earth color, mix a small amount of Burnt Umber with white, and add a small touch of Cadmium Yellow Medium to warm it up. Apply this below the horizon line with a no. 2 flat. Use a no. 2 flat bristle to build up the entire grass area further by scrubbing in the same colors you used in the tree row in step 2 to create texture and to build up the brush below the trees on the right.

For the subtle highlights reflecting off the top of the grass, dab a small amount of light yellow-ochre earth color with the no. 2 flat bristle.

The Trees

Use very fluid paint (add a touch of water to help it flow) and a no. 2 liner. This helps the lines look delicate and tapered on the ends. The trees have extreme contrasts of light and dark. Add the warm brown color with a mixture of Cadmium Red Light, Burnt Umber and a touch of white. Use this mixture with more white for the highlights. Some of the highlights are pure white. Study the example and work for the same effect. Look at where the light is hitting each branch and where the shadows are. The deeper shadows are on the left side of the trees. Add the small dark spots on the tree on the right with little dots, pure black and the tip of the liner.

Red Autumn

Now we can practice painting a tree with lots of beautiful foliage. But before we can get to that, we must create everything around it first. To paint a tree such as this, you must have the entire background done first, so you are not painting *around* it later.

MATERIALS LIST

PAINTS
Alizarin Crimson, Burnt Umber, Cadmium Red Light, Cadmium Yellow Medium, Ivory Black, Prussian Blue and Titanium White

BRUSHES
1-inch (25mm) flat, no. 2 flat bristle, no. 2 liner, no. 2 round bristle

CANVAS OR CANVAS PAPER
12" × 16" (30cm × 41cm)

OTHER
Mechanical pencil, small piece of cellulose kitchen sponge (optional)

1 Basecoat

The Sky

Draw in the horizon line slightly below the center mark. Mix a small amount of Prussian Blue into white, and apply it with a 1-inch (25mm) flat using horizontal sweeping strokes. For subtle clouds, add a bit of white and let it become streaky.

The Foreground

Add Cadmium Yellow Medium to the sky mixture to create chartreuse-green. With the 1-inch (25mm) flat, apply this to the foreground. Create the sidewalk with white and a touch of black.

The Background Trees

Scrub in the illusion of background trees using this same chartreuse green mixture and a no. 2 flat bristle. Vary the colors by adding more yellow for the lighter ones and a touch of Burnt Umber for the darker one on the left. With Burnt Umber, add the darker color in front of the background trees and along the sidewalk.

The Main Tree

Apply the trunk of the tree with a no. 2 liner. Slightly dilute Burnt Umber and Alizarin Crimson, and pull the stroke upward from the base. Apply small strokes to create the branches. With a no. 2 round bristle, dab the look of foliage. Start with Burnt Umber for the darker colors underneath. Add a small amount of Cadmium Yellow Medium to the Burnt Umber for the lighter brown. Add that on top with the same dabbing method. Lighten the color once more by adding a small amount of Cadmium Red Light for an orangey hue. Add some pure Cadmium Yellow Medium to the mix for some highlights.

2 The Awkward Stage

The Background Trees

Build up the background trees a little more using a no. 2 flat bristle. Create darker shades of green by mixing some black into the light green color you used first. Use the scrubbing technique for adding more color. Because they are in the distance, they lose the small details.

The Main Tree

Once the background trees are complete, add more layers to the main tree using a no. 2 round bristle. Use the same colors as before, alternating dark and light. Use a kitchen sponge for a more textured look.

The Shadows

Add the shadow below the tree with a dark green mixture (Cadmium Yellow Medium with a touch of Prussian Blue and a bit of black) using a no. 2 flat bristle. Use this to suggest the pine tree peeking in on the left, too. Add a touch of the reddish colors below the tree on the ground next to the shadow. Use the same colors as you did for the foliage.

Cast Shadow Reminder

The cast shadow is always on the opposite side from the light source. How little or how much of a cast shadow a tree produces is governed by the light source and the direction it is coming from.

Leafy Tree Hints

The dabbing technique is primarily used for painting this type of leafy tree. Try a small piece of sponge to dab on the color. Tearing the sponge, rather than cutting it, produces a ragged edge that creates irregular shapes. Vary the shapes. Leaves appear in clumps. They fill in and overlap one another, creating groups and layers with areas of sky that show through, and you can see the branches of the tree going in and out of the leaves. If you fill in things too much, mix more of the sky color and dab it back in to open it up a bit. I usually start with the darker colors first—the colors that are seen in the darker, recessed areas—then dab the medium and light colors on top of that to create the layers. Layer the colors back and forth, adding dark and light colors until you like the way it looks.

3 Finish

Finishing a painting is all about adding layers.

The Background Trees

Add a bit more highlighting and texture. Don't overdo it, for they must look farther away. Add a small amount of Cadmium Yellow Medium to the trees on the right.

The Main Tree

Once the background trees are complete, continue filling in the main tree, allowing it to overlap the trees in the background and steal the show. Add a bit of highlighting to the tree trunk to make it look textured using a bit of the light green used for the ground. Add some pure Cadmium Red Light for more color.

The Ground

To detail the ground to make it look realistic, use a no. 2 flat bristle and scrub in various colors using a dry-brush application for a speckled appearance. Start with the lighter colors first (lighter green and yellow tones). Apply them over the chartreuse color already there. Return to the shadow area and scrub in some darker colors (black mixed into Burnt Umber) on top of the dark green already there. Don't let this fill in too much. Like foliage, you must be able to see the colors underneath peeking through. Reflect some red tones (Cadmium Red Light and Cadmium Yellow Medium) into the ground also.

RED AUTUMN TREE
16" × 12" (41cm × 30cm)

Snowy Pines

A painting does not have to be complicated to be pretty. Sometimes simple can look elegant and soothing to the eye. I like this piece for its tranquility. It appears calm and peaceful due to its simple composition and pale hues. Follow along to create this simple snow scene. The bulk of this painting was created with the blending technique.

MATERIALS LIST

PAINTS
Alizarin Crimson, Burnt Umber, Dioxazine Purple, Ivory Black, Prussian Blue and Titanium White

BRUSHES
1-inch (25mm) flat, no. 2 liner, no. 2 round bristle, no. 2 round sable or synthetic

CANVAS OR CANVAS PAPER
11" × 14" (28cm × 36cm)

OTHER
Mechanical pencil

1 Basecoat

The Sky

Draw the horizon line slightly above the center mark. Paint the sky with long strokes, using a smooth application of paint and a 1-inch (25mm) flat.

The sky is darker at the top, gently fading in color as it approaches the horizon line. Begin with the basic Prussian Blue and white sky mixture. At the top where it is darker, add a tiny bit of Dioxazine Purple. As you move down, keep adding more white until it fades into the horizon line.

The Background Trees

Mix a deep blue-gray color by adding black into the darker sky color used before. Drybrush in the illusion of background trees along the horizon line using a no. 2 round bristle.

The Foreground

Using the same color you used for the trees, fill in the shape of the pond and the rocks using a no. 2 round sable or synthetic. Fill in the entire snow area with white. Add a small amount of the lighter sky-blue color, and create the look of subtle shadows.

2 The Awkward Stage
The Background Trees

Use the scrubbing/dry-brush technique to make the distant trees look farther away and a bit out of focus. For more depth and distance, apply a small amount of brownish pink in the back of them using white, a touch of Alizarin Crimson and a very small touch of Burnt Umber. With a no. 2 round bristle, scrub in this light pink color over the darker color you already applied. With black and Burnt Umber mixed together, create the illusion of trees in the background. Scrub in the ones on the left. Use a no. 2 liner on the right for more detail. Dilute the paint a little. Create a light gray color by mixing black and white together. Add some water to it to make it fluid. Using the no. 2 liner, pull up the tree trunks of the trees on the left. Add a bit of this color to the rocks below them.

The Snow

Drybrush a bit more of the blue tones, as well as some of the pinkish color from the background. Only the highlight areas appear to be bright white.

The Pond

Using the no. 2 round sable/synthetic, take a small bit of black that has been thinned with some water, and add it to the water area along the shoreline.

Black and White

Black isn't black, and white isn't white. Both of them are neutrals and are very reflective. You will never see pure black or pure white in nature. They will be reflecting all of the surrounding light, shadows and colors. This is a perfect example. Your brain tells you that snow is white. We all know that. But, if you observe it in nature, it will rarely appear to be pure white. In this case, the snow is really made up of pastel shades of blue and pink. It may be subtle, but it's true.

3 Small Details to Finish

The Background Trees

Drybrush the distant trees to keep them looking out of focus. Add snow using a no. 2 flat bristle and scrubbing a small amount of white into them. Add some tiny tree trunks with the liner and some gray. Make them interrupted lines that seem to go in and out of the foliage. For the closer trees, use a no. 2 round sable/synthetic and not much paint to randomly dab in snow so it looks different from tree to tree.

The Larger Trees on the Left

With a light gray (black and white) add a few limbs with the no. 2 liner. Thin down some black and add a shadow along the right side of the trunk for dimension. With a medium gray (black and white), dab some foliage onto the limbs with a no. 2 round bristle. When it's dry, add white on top for the look of snow using the no. 2 round sable. Be random! Add ice and snow to the rocks below.

The Pond

Since water is reflective, drybrush all the colors from the surroundings into the water using the no. 2 round bristle: light blue, grays and a touch of pink. Make horizontal strokes across the water, creating the illusion of reflection along the shorelines. The white of the ground reflects along the water's edge. The ground and the water are separated by a subtle gray shadow. Add some bright white in the highlight areas directly above the pond, on top of the rocks and along the top of the little island in the water.

SIMPLE SNOW SCENE
14" × 11" (36cm × 28cm)

Pastel Winter

Unlike the trees of the previous project, these winter trees have a much softer appearance. The pastel colors are beautiful, and the simple composition is fun to paint.

MATERIALS LIST

PAINTS
Alizarin Crimson, Burnt Umber, Cadmium Red Light, Dioxazine Purple, Prussian Blue and Titanium White

BRUSHES
1-inch (25mm) flat, no. 2 flat bristle, no. 2 liner, no. 2 round bristle

CANVAS OR CANVAS PAPER
9" × 12" (23cm × 30cm)

OTHER
Mechanical pencil, small piece of cellulose kitchen sponge (optional)

1 Basecoat

The Sky

Start with the back and work to the front. Draw the horizon line slightly below center. Using a 1-inch (25mm) flat, begin with the sky. It is light blue on the top (white with a touch of Prussian Blue added). As you move down, add more white and a small amount of Alizarin Crimson to make a subtle lavender color. It becomes pinker the closer it gets to the horizon line. At the horizon line, it becomes more violet. Add a touch of Dioxazine Purple for that.

The Foreground

Fill in the foreground below the horizon line with a diluted pale pink. With thinned down Burnt Umber and a no. 2 liner, add the horizontal line for the sidewalk.

The Trees

With a no. 2 liner and diluted Burnt Umber, apply the vertical lines that represent the tree trunks.

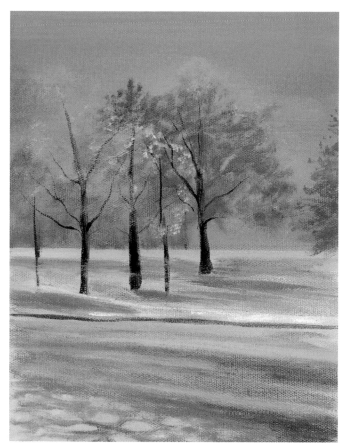

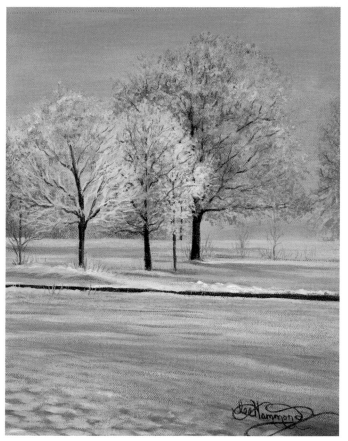

2 The Awkward Stage
The Background Trees
Mix a violet with Dioxazine Purple and Titanium White, and use drybrushing to scrub in the trees with a no. 2 round bristle.

The Foreground Trees
Pull thin lines for branches with diluted (inklike consistency) Burnt Umber and a no. 2 liner. Extend the branches with small, tapered lines. With violet, drybrush the beginning of the foliage into the main tree in the center and the suggestion of the tree on the far right. Drybrush pink (white and a touch of Alizarin Crimson) with a circular stroke above and behind the main trees for a halo effect.

The Foreground
Scrub in some of the patterns in the ground snow. Start with the same violet you used for the trees and streak it with a no. 2 flat bristle. In the lower left, form rocks with circular shapes. Add a tiny bit of Prussian Blue to the mix for the bluish streaks. There is a large streak directly behind the trees and more toward the front. Add some white along the top of the sidewalk for a snow drift. Add a little Cadmium Red Light to the white to make a pale pink. Start dabbing in the trees to make pretty foliage.

3 Finish
The Trees
Dab with the pale pink you just mixed for the fullness of the trees. Use either a no. 2 round bristle or a piece of kitchen sponge. Keep dabbing until the trees look full. Strengthen the trunk colors and create the look of the tiny limbs going in and out of the foliage. Apply the limbs with diluted Burnt Umber and a no. 2 liner. Add some Cadmium Red Light to the Burnt Umber for the reddish hue on the tree on the left. Once the limbs are in, continue adding more foliage on top of them. Add more white to the pink mixture for the last layers for highlights, using less on the tree on the right.

The Foreground
Using a no. 2 flat bristle, drybrush streaks of light pink to the ground for the sunshine. Add this to the textured area in the foreground as well. Continue adding streaky dry-brush layers, alternating colors for shadows and sun streaks. Add tiny grasses with a no. 2 liner, using pale shades of lavender and very quick strokes that taper. Deepen the color of the sidewalk with Burnt Umber.

PASTEL WINTER
12" × 9" (30cm × 23cm)

Grass

Grass is an important detail in landscape painting. It plays an important part in telling the story. Like foliage, grass is painted in many layers to create its volume and depth. It is done with a small round or liner brush with quick tapered strokes.

MATERIALS LIST

PAINTS
Burnt Umber, Cadmium Red Light, Cadmium Yellow Medium, Ivory Black, Prussian Blue and Titanium White

BRUSHES
1-inch (25mm) flat, no. 2 flat bristle, no. 2 liner, no. 2 round bristle

CANVAS OR CANVAS PAPER
8" × 10" (20cm × 25cm)

1 Basecoat

As with everything else, the background must be put in first. Apply the sky color with a mixture of white and Prussian Blue and the 1-inch (25mm) flat. Allow the sky to become lighter by adding more white as it approaches the horizon line.

Separate the sky from the ground with a thin line of Burnt Umber painted with the no. 2 liner. Create a cream color by mixing a small amount of Cadmium Yellow Medium into some white and apply this directly below the horizon line using a 1-inch (25mm) flat. Add some Burnt Umber to deepen the color and keep on moving down. Keep adding Burnt Umber until it becomes darker and darker. At the bottom, add some black for the deepest tone of all.

2 The Awkward Stage

Reflect some of the sky color onto the ground. Mix a warm brown with white, Burnt Umber and a touch of Cadmium Red Light. Apply this along the horizon line using a no. 2 flat. Streak some of the sky-blue color across the ground directly below the horizon line.

Move to the middle ground and begin layering dark grass strokes with Burnt Umber using a no. 2 liner. Make the strokes quick with tapered ends. Bend them off to the left side to make it appear that the wind is blowing, and keep in mind that the grass appears taller in the foreground and shorter as it goes back because of distance and perspective.

Once you have a good start with the dark strokes, add medium ones on top of those using a no. 2 liner (add a bit of white and a touch of Cadmium Yellow Medium to the Burnt Umber). After that add a bit more white to the mix and layer on the lighter strokes.

3 Finish

Continue the quick strokes with a no. 2 liner until they build up like mine. Allow the strokes to overlap and fill in. The final layers should be with extremely thin lines, especially those in the very front. Build up the many layers of grass until it looks real. Do not stop too soon. The more layers, the more realistic it will appear!

PRAIRIE GRASS
10" × 8" (25cm × 20cm)

Wildflower Sunset

This composition is all about the grass and flowers. The horizon line is above center, allowing more room for the foreground. Warm gold and yellow tones reflect off the edges of the tree row and the grass at the horizon line, creating a powerful wash of color. The colors of the yellow wildflowers repeat the yellow colors around the composition. As the ground gets farther away, the vertical elements of the grass fade, and the patterns of the grass in the distance change to horizontal streaks instead. This creates the illusion of distance. While we know that the field is covered with wildflowers, they become less distinct the farther away they get. Horizontal patterns that get closer together as they recede always represent depth.

MATERIALS LIST

PAINTS
Alizarin Crimson, Cadmium Red Light, Cadmium Yellow Medium, Ivory Black, Prussian Blue, and Titanium White

BRUSHES
1-inch (25mm) flat, no. 2 flat bristle, no. 2 liner, no. 2 round sable or synthetic

CANVAS OR CANVAS PAPER
12" × 16" (30cm × 41cm)

OTHER
Mechanical pencil

1 Basecoat

The Sky

Draw the horizon line on your canvas above center. The base color for this sky is a mostly Cadmium Yellow Medium. Use the 1-inch (25mm) flat and sweeping horizontal strokes to completely fill in the sky with this color. Take the sky clear down to the horizon line, so the trees can be placed over it later. Using the same brush, begin the clouds, both light and dark, giving it a streaky appearance. For the deeper colors add some Alizarin Crimson to the yellow. For the lighter streaks, add some white to the yellow. Go back and forth with this combination of colors until you like the look of your sky. Do not put in the sun yet.

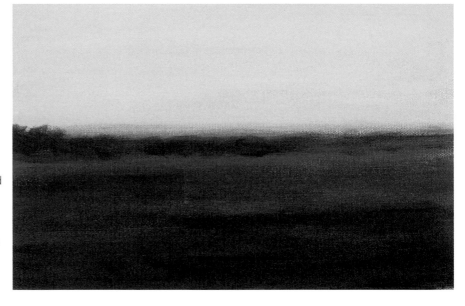

The Foreground

Mix an olive green by adding a small amount of Ivory Black into Cadmium Yellow Medium. With the 1-inch (25mm) flat, apply this to the entire foreground area.

The Background Trees

Add more black to make a darker green and scrub in the tree row with a circular stroke and a no. 2 flat bristle.

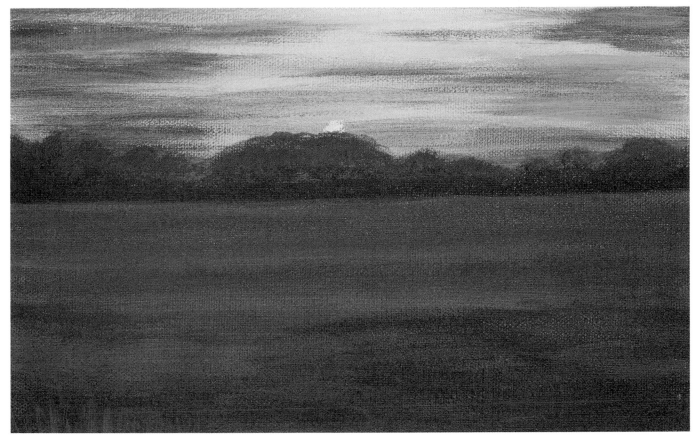

2 The Awkward Stage

The Sun

After the trees are scrubbed in, create the sun-glow effect by drybrushing an orange color over the trees with a no. 2 flat. This color is created by mixing a small amount of Cadmium Red Light with some Cadmium Yellow Medium. Use a very small amount of paint so it stays subtle and not heavy. Add the small circular sun area in the center above the trees. Use pure white for this and a no. 2 round sable or synthetic. Create the sun-ray effect with a no. 2 flat, using the orange color and strokes that follow a wagon-wheel direction, coming out from the center of the sun area into the trees.

The Foreground

With the same no. 2 flat, drybrush across the grass at the horizon line. Use the edge of your brush, holding it upright as you go across horizontally. This creates the illusion of flowers in the distance along with the golden glow of the sun.

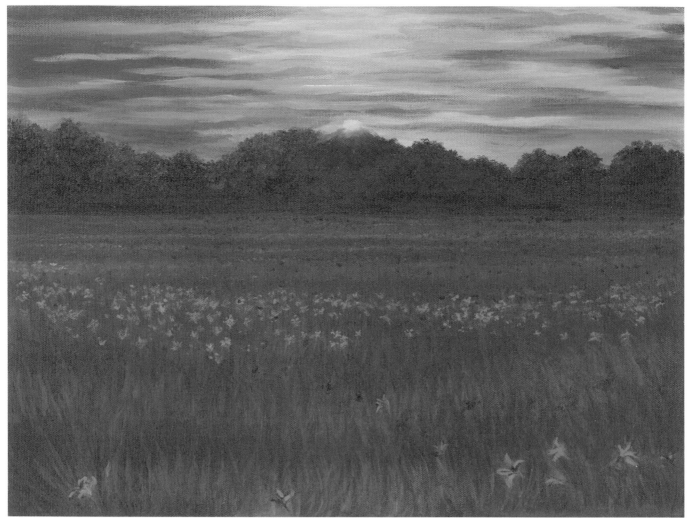

3 Finish

The Grass

With a no. 2 round sable or synthetic and medium green (Cadmium Yellow Medium and a tiny amount of Prussian Blue), use quick vertical strokes for grass. The strokes are much longer in the foreground than in the background. Do not fill in the grass too much. There are bands of light and dark that create the illusion of distance. If things fill in too much, mix a darker green (yellow and black) and add the dark back in with the same vertical strokes. For the grass closest to the bottom, use a no. 2. These will become stems for the flowers.

The Flowers

Begin with the background flowers, dabbing Cadmium Yellow Medium across the page with the no. 2 flat. Holding it upright, use the edge and a small amount of paint. Create a subtle band of yellow. Continue this, moving forward, allowing more distance between the bands the closer you get to the bottom. Switch to a no. 2 round sable or synthetic and create the illusion of flowers in the middle of the grassy area. Keep it random. No two are exactly alike—some are like dots and some look like triangles. Don't try too hard to make them look like flowers or "marching along" in rows. Create larger flowers in the foreground. This is where you can make them actually look like daylilies. Follow the same steps as before using the dabbing technique, creating "dots," but this time using Cadmium Red Light. This will enhance the look of the sunglow. Use the same dry-brush application as used in step 2 to add some of the Cadmium Red Light and Cadmium Yellow Medium to the grass. Use the Cadmium Red Light to create the illusion of red centers in some of the flowers, being careful not to make them all look alike.

WILDFLOWER SUNSET
12" × 16" (30cm × 41cm)

Country Trees and Wildflowers

This painting has many of the same elements as the previous project, even though the lighting is totally different. This time the sun is high, and it appears to be midday. What remains the same is the illusion of distance due to the bands of light and the abstract handling of the wildflowers.

MATERIALS LIST

PAINTS
Alizarin Crimson, Burnt Umber, Cadmium Red Light, Cadmium Yellow Medium, Dioxazine Purple, Prussian Blue and Titanium White

BRUSHES
1-inch (25mm) flat, no. 2 liner, no. 2 round, no. 2 round bristle

CANVAS OR CANVAS PAPER
9" × 12" (23cm × 30cm)

OTHER
Mechanical pencil

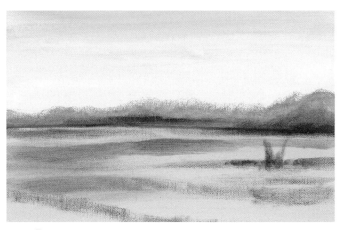

1 Basecoat

The Sky

Draw in the horizon line above center. Paint the sky with a white and Prussian Blue mixture and a 1-inch (25mm) flat. Allow the colors to remain streaky for the illusion of clouds.

The Foreground

Below the horizon line, fill in the entire ground area with a pale yellow-green. Mix this with Cadmium Yellow Medium and a tiny bit of Prussian Blue. Separate the sky from the ground with a horizontal line of Burnt Umber. Paint using a no. 2 round. Mix Cadmium Yellow Medium into the Burnt Umber, and scrub in the tree row in the distance directly above the horizon line with a no. 2 round bristle. Streak some of this color into the ground area as shown. Mix a deep green with Cadmium Yellow Medium and Prussian Blue and streak this into the ground also.

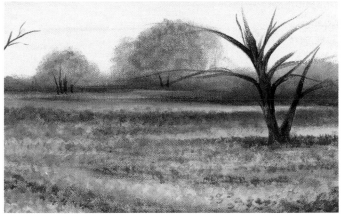

2 The Awkward Stage

The Trees

Apply the vertical lines for tree trunks into the horizon line using a no. 2 liner and diluted Burnt Umber. With the same color used for the tree row, scrub in the first layer of foliage into the background trees. With Burnt Umber, create the larger tree trunk in the front right. Use a no. 2 round for the trunk and switch to a no. 2 liner for the smaller limbs. Add the little limb peeking in from the left.

The Grass

Drybrush the ground colors with a no. 2 round bristle. Create the bands of color using a circular stroke and going across the painting horizontally, starting with the golden tones of the middle ground with the same color used for the tree row, then deepened with a touch of Cadmium Red Light. Add some red tone around the base of the trunk. Add streaks with shades of green (mix a little Prussian Blue into Cadmium Yellow Medium).

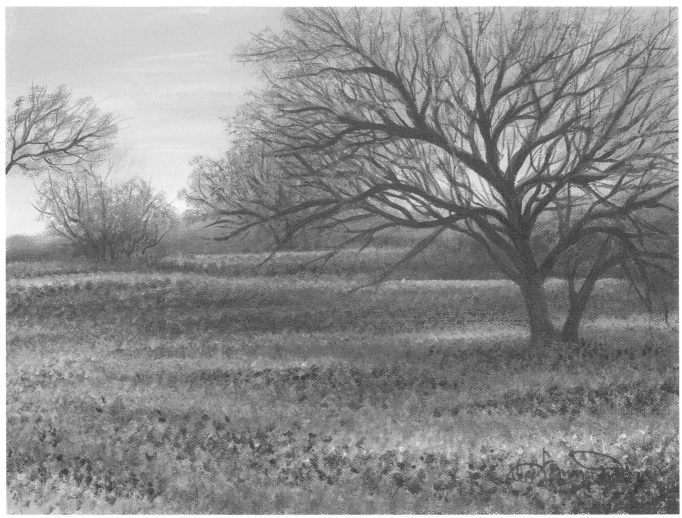

3 Finish

The Trees

Use the liner to add more limbs to the trees. Alternate the colors, adding both dark and light limbs to fill the trees out: Burnt Umber for darker limbs, Cadmium Red Light and Cadmium Yellow Medium added to the Burnt Umber for a golden look for the lighter ones. Add the lighter mixture to the left side of the trunks for a sunlit look. Dab the trees in the back (using the same colors as the ones in front) to make them look more out of focus.

The Foreground

Continue to build up the horizontal bands of color using lots of different colors, alternating and overlapping them. The colors in the background seem to fade together due to distance, while the colors in the foreground are very distinct. This is like stippling. It is a pattern of dots that makes the illusion. Use as many different colors as possible. I used Alizarin Crimson and Cadmium Red Light right out of the tube for brightness. Feel free to experiment with this one.

The Background

The colors in the background are warmer with the use of golden yellows and oranges. I mixed a little of the Dioxazine Purple into the orangey colors for a muted red-violet. There really is no right or wrong. Your painting does not have to look exactly like mine. Use you favorite colors to make your painting unique.

COUNTRY TREES AND WILDFLOWERS
9" × 12" (23cm × 30cm)

Flowering Bush

You've learned how to use flowers to brighten up a landscape. They can be a wonderful addition to your composition. But up until now, we have dealt with flowers as they are seen in the background. This project will bring the flowers up closer and give you practice painting them with more detail.

MATERIALS LIST

PAINTS
Alizarin Crimson, Burnt Umber, Cadmium Red Light, Cadmium Yellow Medium, Dioxazine Purple, Ivory Black, Prussian Blue and Titanium White

BRUSHES
1-inch (25mm) flat, no. 2 liner, no. 2 round bristle, no. 4 flat, no. 2 round sable or synthetic

CANVAS OR CANVAS PAPER
12" × 9" (30cm × 23cm)

1 Basecoat

The Sky

Make the horizon line high to leave room for flowers in the foreground. The sky is barely seen due to the foliage; you paint it so it can be seen through the trees. Use a sky-blue mixture (white and Prussian Blue) to paint the sky to the horizon line with a 1-inch (25mm) flat.

The Foreground

Mix a green with Prussian Blue, white and Cadmium Yellow Medium, and apply this to the foreground, from horizon line to the bottom, with the 1-inch (25mm) flat. Keep the paint fairly thin. Apply a line of Burnt Umber along the horizon line with a no. 2 round sable or synthetic to separate sky from ground.

The Tree Row

In the background, use thicker paint to create the tree row with the green mixture deepened with a little more Prussian Blue. Scrub in the trees with a circular stroke, a dry-brush application and a no. 2 round bristle. Create a pinkish color (white, Alizarin Crimson and a little Burnt Umber) to go in front of the green trees in the background. Use the same technique for the pink bushes. Add a small patch of black between the two pink bushes to create an entry to the background. Mix a yellowish green by adding some Cadmium Yellow Medium to the green mixture. Scrub in a small hedgerow along the horizon line.

The Large Bush

Using the same dark green and the scrubbing technique used for the tree row, apply the large mass along the left side.

The Main Tree

With Burnt Umber and a no. 2 round sable or synthetic, apply the tree trunk and limbs.

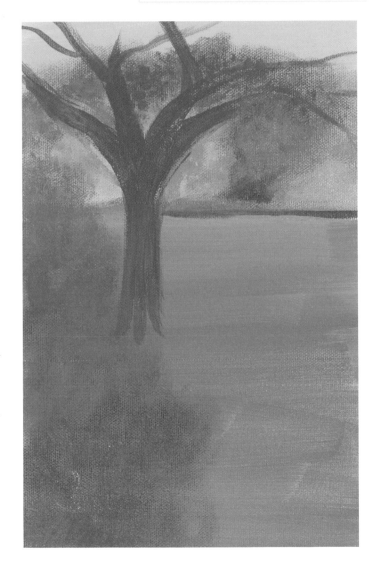

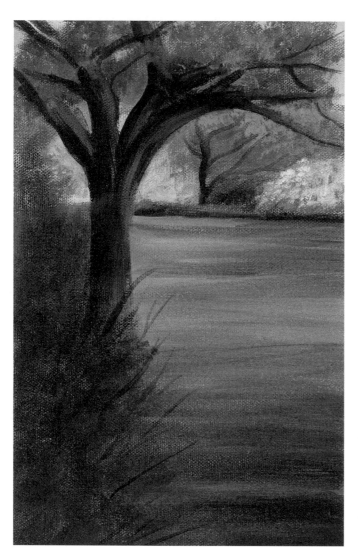

2 The Awkward Stage

The Background Bushes

Add some light texture to the pink bushes in the back by dabbing a mixture of a very small amount of Cadmium Red Light to some white on top of the bushes with a no. 2 round bristle. With black and a no. 2 liner, add the trunk and limbs to the recessed area in the background.

The Main Tree

Deepen the colors of the trunk to create realism and a sense of a light source. Make the light side by adding Cadmium Red Light to some Burnt Umber and white. Make the dark side with Burnt Umber mixed with black. Apply these colors with a no. 2 round sable or synthetic. Mix more of the yellowish green that you used along the horizon line and apply it to the main tree. Use the no. 2 round bristle and dab this to create foliage.

The Large Bush

With a no. 2 liner, dilute some Ivory Black and add the small limbs in the large bush on the left side. Deepen the color of the large bush on the left by adding some Ivory Black to the green mixture. Scrub it in with the no. 2 round bristle.

The Grass

With a no. 4 flat, streak the grassy area with the yellowish green mixture used for the trees' foliage. Add some of the darker green color towards the bottom, using the same streaky approach.

Tip

Refer to page 69 for help finishing the flowers on the bushes.

3 Finish

The Main Tree

Keep dabbing to build up the colors in the foliage. Make the leaf colors by mixing a small amount of Ivory Black into some Cadmium Yellow Medium for an olive green. Lighten the olive color by adding some white. Dab that over the green that you applied in step 2. Add some Cadmium Red Light to the olive mix, and dab that on the top of the light olive color to create a warm glow.

The Background Bushes

Use that warm orangey color for the foliage in the background bushes and in the warm streaks in the grass. Dab a bit of black into the small recessed area between the bushes in the background to make it look darker and farther away. Create the illusion of small bushes back there with black. Reapply the small limbs of the tree if necessary.

The Flowers

Complete the exercise on page 69 if you haven't already. Once you have mastered them on a practice piece of paper, apply the same techniques to the large flowering bush.

FLOWERING BUSH
12" × 9" (30cm × 23cm)

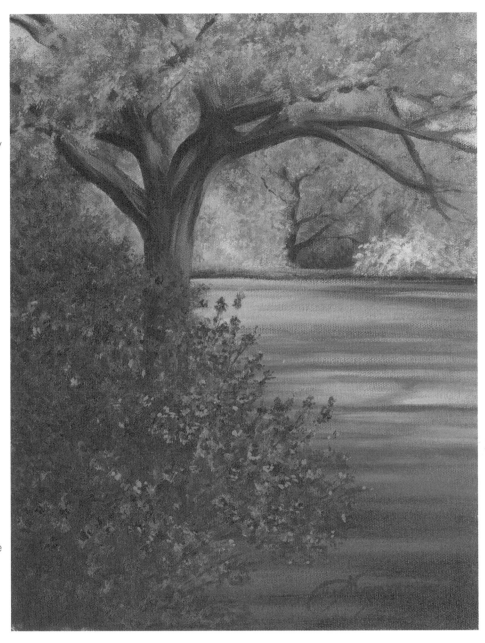

Purple Mountains

This beautiful painting would look great painted on a large scale. It would be a perfect over-the-mantel painting for a living room or large wall, so feel free to make this as big as you like. Just adjust the size of your brushes accordingly. Refer to the final painting as you work.

MATERIALS LIST

PAINTS
Alizarin Crimson, Cadmium Red Light, Dioxazine Purple, Ivory Black, Prussian Blue and Titanium White

BRUSHES
½-inch (13mm) flat, 1-inch (25mm) flat, no. 2 flat bristle, no. 2 round sable or synthetic

CANVAS OR CANVAS PAPER
9" × 12" (23cm × 30cm)

OTHER
Mechanical pencil

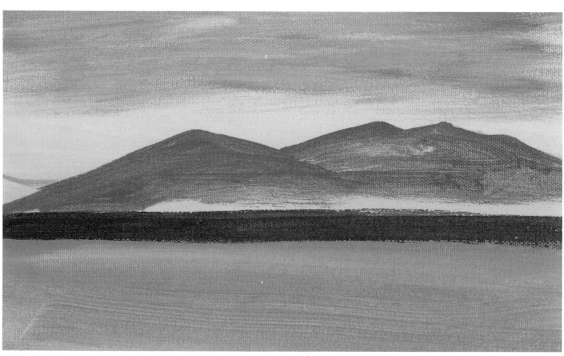

1 Basecoat

The Sky

Draw a horizon line that is below center. With a 1-inch (25mm) flat, base in the entire sky area with a very pale blue (tiny bit of Prussian Blue added to white). Carry this color clear to the horizon line. Once this is dry, mix a shade of lavender with Titanium White, a small touch of Alizarin Crimson and a touch of Dioxazine Purple. Apply this across the top of the sky area with horizontal sweeping strokes to start the cloud layers. Add a small amount of Cadmium Red Light to make a lighter shade of pink, and streak that into the sky as well.

The Lake

Below the horizon line, fill in the lake area with a darker shade of blue and the 1-inch (25mm) flat. Add a touch more Prussian Blue to the original sky mix.

The Hill

With pure Ivory Black and the no. 2 round sable or synthetic, add the small hill area directly above the waterline along the horizon line.

The Mountains

Mix a slightly darker shade of lavender with white, a small touch of Alizarin Crimson and a touch of Dioxazine Purple. Apply this to the mountain range.

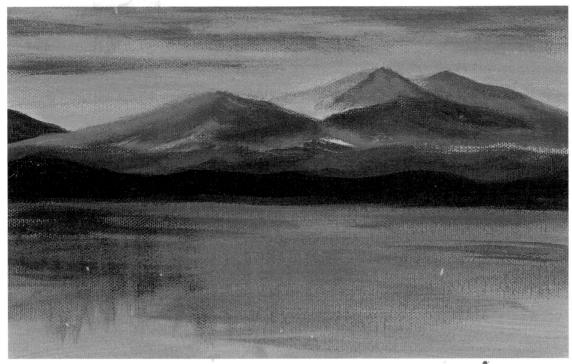

2 The Awkward Stage

The Sky

Create a violet-blue with Dioxazine Purple, Titanium White and a touch of Prussian Blue. Starting at the top, apply this with sweeping strokes and the ½-inch (13mm) flat. This color will be streaking through the sky with other colors layered over it. Continue layering and blending colors into the sky to create the streaky stratus clouds. Vary the colors by adding hints of purple and pink. For the lighter clouds, create a salmon pink by mixing Cadmium Red Light with Titanium White, and streaking that color into the others. Enhance the clouds with a touch of Titanium White. Finish the sky before continuing with the mountains. The streaks need to look as if they are going behind the mountains, not around them.

The Mountains

Using the same colors as you did for the clouds and the no. 2 round sable or synthetic, apply the details in the mountains. All the sky colors are reflected. Keep lighter colors on the left. The mountains are made up of light, medium and dark shades. The darkest one has already been applied. Use the salmon pink to enhance the peaks. Add a little white to this for the lighter areas. The darker area on the lower right side is made by mixing Alizarin Crimson with a little white. Paint in the color of the small mountain range in front using a blue-gray (a small dab of Prussian Blue into white), then adding a touch of black. When that is dry, drybrush Cadmium Red Light over them for a red glow. With black and the no. 2 round sable or synthetic, give the dark hills in front a curved shape.

The Water

All the colors of the mountains reflect into the water below. Use horizontal and vertical brushstrokes and a no. 2 flat bristle to drybrush streaks of the colors used for the sky and the mountains into the water area to create the mirror image on the water's surface. Don't fill it in too much. Allow the light edge of blue to remain along the shoreline. Continue streaking the sky with pastel shades of purple, pink and white.

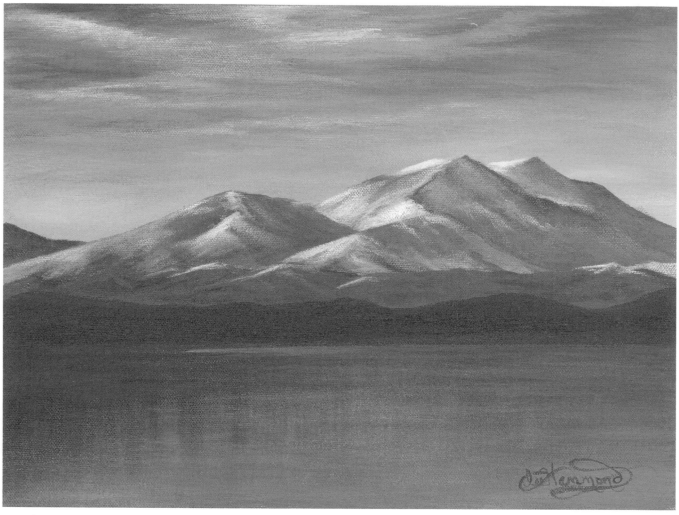

3 Finish

The Sky

Continue drybrushing layers of colors into the sky with horizontal streaks using lavender and pink colors until your sky looks similar to mine. Use the no. 2 round sable or synthetic. Allow the light blue to show behind the mountains.

The Water

Drybrush pink tones into the water to reflect the mountain using a no. 2 flat bristle. Use back-and-forth and up-and-down strokes. Allow the dry-brush application to show. Drybrush some Ivory Black into the water on the left. Notice how the reflections go both back and forth and up and down. This is because the movement of the water interrupts the reflection. Use your no. 2 flat bristle in both directions to achieve this, being careful not to allow it to fill in and look too solid. If it does, drybrush the lighter blue color back into it to break it up. Apply a light blue reflection (small amount of Prussian Blue into Titanium White) along the water's edge directly below the black hills. Turn the no. 2 flat on edge to create a sharp edge here that is straight across.

Ultimate Mountain Scene

This is another mountain scene that would look lovely on a larger scale. Feel free to make this one huge to show off its beauty. If you have followed the exercises and projects in the book so far, you should have all of the experience you need to complete this painting. It may look complicated, but it really isn't. Follow along for the ultimate mountain challenge!

MATERIALS LIST

PAINTS
Alizarin Crimson, Burnt Umber, Cadmium Red Light, Cadmium Yellow Medium, Dioxazine Purple, Ivory Black, Prussian Blue and Titanium White

BRUSHES
½-inch (13mm) flat, 1-inch (25mm) flat, no. 2 round sable or synthetic, no. 2 liner

CANVAS OR CANVAS PAPER
9" × 12" (23cm × 30cm)

OTHER
Mechanical pencil

1 Basecoat

The Horizon Line

Draw in a horizon line that is a little below center. With Burnt Umber, Ivory Black and a no. 2 round sable or synthetic, paint across the horizon line and create the shapes of the mountains and hills to separate the sky from the water. Create the shape of the small rock formations in the water below.

The Sky

Using the 1-inch (25mm) flat, streak in the sky with a light blue (Titanium White and a touch of Prussian Blue), light yellow (Tita-nium White and a touch of Cadmium Yellow Medium) and a pink (small amount of Alizarin Crimson into some Titanium White).

The Water

Use the same brush and same paint mixtures to streak color into the water area.

The Distant Mountain

Using the no. 2 round sable or synthetic, fill in the small mountain range in the far right and the small rock formation in the right foreground with a blue-gray (add a small amount of Ivory Black into the sky color).

2 The Awkward Stage

The Sky

Create the beautiful cloud formations and finish the sky before moving on to the mountains. (See pages 50–55.) Start with the largest cumulus cloud on the right, and base it in with a light yellow (Cadmium Yellow Medium and Titanium White). Add a bit of Cadmium Red Light to this mixture and scrub in the orangey colors so it looks airy. Add violet (mix Dioxazine Purple with some Titanium White) to the clouds as well. Layer all these back and forth until you like the look of your clouds. Take the same colors and reflect them into the water directly below in a mirror image. Use the 1-inch (25mm) flat and horizontal strokes. Allow the images to remain drybrushed and streaky.

Move to the left side and use the same technique to create the smaller cloud formations, remembering that two clouds are never alike.

The Mountains

Using a ½-inch (13mm) flat, fill in the colors of the mountains as shown. The darker ones are combinations of Burnt Umber and Ivory Black. The lighter one on the left has Burnt Umber on top and an orange below (Cadmium Yellow Medium mixed with a small amount of Cadmium Red Light).

The Water

Streak the brown tones from the Burnt Umber and Ivory Black mixture of the mountain into the water using a ½-inch (13mm) flat. Add a few more rocks with a no. 2 round sable or synthetic and the same brown tones of the mountains. This stage is not polished so the paint can be a bit thin here.

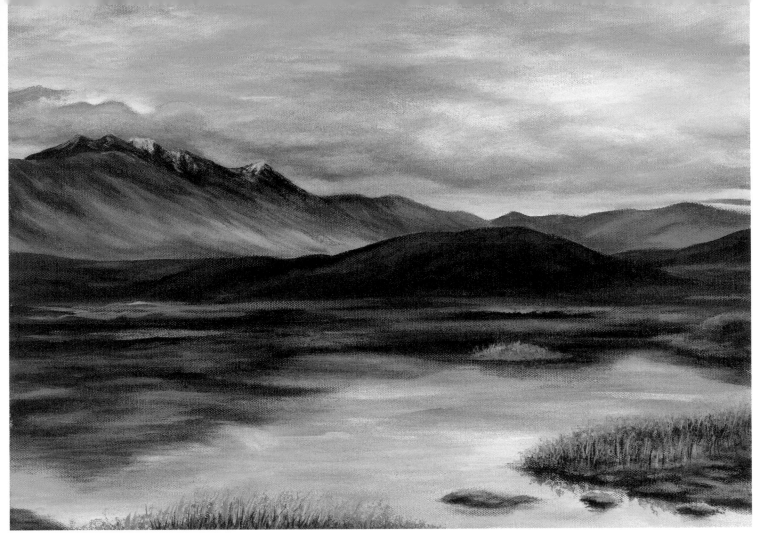

Finish

Study this finished example carefully, and you can see where the additional work has been applied. Add the details to your painting in this order:

The Sky

Continue until it is realistic and colorful. If you have filled in too much, mix more sky blue (see Step 1) and streak it back in. Add pastel colors to the cloud formations until they look real.

The Mountains

Add details with dry-brush applications. There are some pinky pastel snowy peaks on the left. Add these to the mountain peaks with a no. 2 round sable or synthetic and Cadmium Red Light and white. Drybrush this color to the smooth area of the mountain in the middle. Drybrush a cooler pink (Alizarin Crimson and Titanium White) to the gray mountain on the right with a no. 2 round bristle. Add this color to the dark brown mountains in the front, too. For the orangey color of the mountain on the left, streak in the pink Alizarin Crimson mixture again with a no. 2 round sable or synthetic with diagonal strokes, then highlight that with a light yellow (Cadmium Yellow Medium and Titanium White).

The Water

Using horizontal strokes applied with a no. 2 round sable or synthetic, streak various colors from the painting above into the water area. It is a mirror image, so pay attention to the shapes. Alternate the colors until it looks similar to mine. Like the sky, if it fills in too much, just streak back in with the sky blue.

The Plants

Create a light olive green by mixing Cadmium Yellow Medium with a touch of Ivory Black. Add a bit of Titanium White to the mixture to lighten the tones. Use quick strokes with a no. 2 liner to create the grass on the rock formations. Alternate the brown and orangey colors seen in the mountains, too, using light, medium and dark tones to bring the grass to life.

MOUNTAIN SCENE
9" × 12" (23cm × 30cm)

Garden Walkway

This project will teach you how to create more decorative rocks. This walkway does not have the natural appearance of beach rocks. It has more of a planned look, so each stone must be addressed individually. Follow along to create this garden path.

MATERIALS LIST

PAINTS
Alizarin Crimson, Burnt Umber, Cadmium Red Light, Cadmium Yellow Medium, Dioxazine Purple, Ivory Black, Prussian Blue and Titanium White

BRUSHES
No. 2 flat bristle, no. 2 liner, no. 2 round bristle, no. 2 round sable or synthetic

CANVAS OR CANVAS PAPER
9" × 12" (23cm × 30cm)

OTHER
Mechanical pencil

1 Basecoat

Because of this unique composition, we do not see the sky at all. All the focus is on the ground.

The Walkway

Pencil in the S-shape that represents the walkway. Mix a touch of Ivory Black into Titanium White, then add a touch of Burnt Umber to create a warm gray to fill the walkway in using a no. 2 flat bristle. Toward the back the color gets darker, so add some more Ivory Black to this area.

The Grass

Mix a nice green with Cadmium Yellow Medium and Prussian Blue. Make a light version of it with more Cadmium Yellow Medium and a darker version with a dab of Ivory Black added. Use the no. 2 flat bristle to apply the green tones as seen in my example.

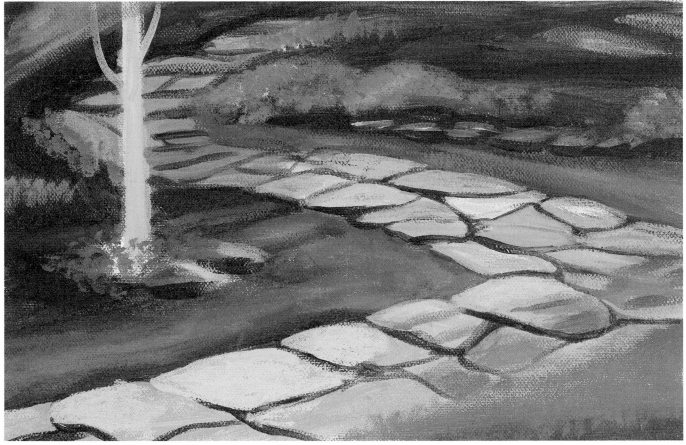

2 The Awkward Stage

The Walkway

Thin some Ivory Black to an inklike consistency. With a no. 2 liner, carefully outline the shapes of the stepping stones. You can draw them with a pencil first to get the shapes right. They do not have to be exactly like mine. The most important thing is that they are larger up close and smaller farther away. Then add some different colors to the stones. The ones in back have the darker gray that we first applied still showing. The ones to the right of the tree have a lavender (Titanium White and Dioxazine Purple). With the no. 2 round sable or synthetic, dab some lavender for flowers on the upper left of the walkway and along the top. Use this to streak across the walkway and in the stones in the lower right corner. For a warm gray with a reddish tint, mix a small amount of Burnt Umber into Titanium White, add a touch of Cadmium Red Light into that, and highlight the stones in the middle right region of the walkway. Add some to the stones in the lower left as well.

The Tree

Using the same gray used for the walkway, add the tree trunk using a no. 2 round sable or synthetic. Add a couple of large rocks to the right. Deepen the gray with Ivory Black and Burnt Umber and scrub in the darkness around the tree and on the shadows of the rocks. Use Ivory Black to create a deep shadow underneath them. Add some rocks to the right of the walkway in the grassy area. Use the same colors and techniques described above for creating them.

The Foliage

Add a little yellow to the green mixture you used for the grassy areas to brighten it up, and use this and a no. 2 flat bristle to scrub some light into the grass in the upper left corner and some foliage into the lower right corner. Create the look of small bushes to the right of the walkway, too. Loosely apply this color to the left of the tree and in the upper right corner.

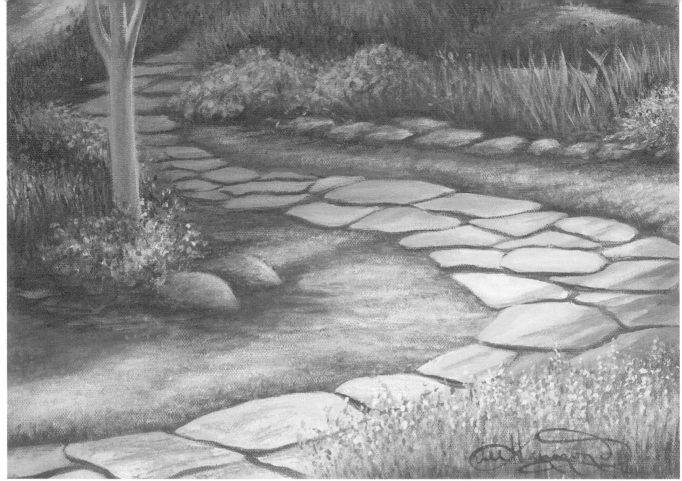

Finish

The Tree

With medium gray (Titanium White with Ivory Black), drybrush the shadow edges of the tree down the center of the trunk and both limbs with a no. 2 round bristle. With a liner, apply the light edges to the trunk and limbs. Use pure white on the right. Add a hint of Prussian Blue on the left.

The Rocks and Stones

Apply the light blue to the stones to the right of the tree with a no. 2 round. Make the rocks next to the tree larger and rounder, reflecting subtle blue tones. The large rocks in the upper right-hand corner are hidden in the background. Complete them using the same process. Reflect some of the light color off of the tops with Titanium White added to the grass color.

The Walkway

Go from stone to stone adding touches of color and highlights. Use a lot of light green and white in the middle stones. Follow the example and carefully add color here and there. For the stones in the lower right, use the no. 2 round sable or synthetic to paint their shadows with blue and gray tones and a bit more control.

The Flowers and Plants

Add as many plants and flowers as you like. Start with the area behind the tree in back of the walkway. Work on top of the dark green. Mix more dark green and scrub it in with a no. 2 round bristle to look like stems. Add some stems with a liner along with a few dots here and there. With the same liner, lightly dot in flowers over the dark green using a variety of colors, from deep Alizarin Crimson to pure Cadmium Red Light and lavender and pink. Create lavender flowers on either side of the walkway with the liner and quick vertical strokes. Add some grass with a variety of green tones as you work along the back. Go across the canvas and behind the large rocks. Dab and dot greens in front of the purple flowers. With the liner, dot in the other lavender flowers on the left side of the walk. With a variety of greens, dab in the bushes right behind the row of rocks on the right with a no. 2 round bristle. As you move to the right, switch to the liner and create a grassy impression. Again, use a variety of greens. Add a hint of flowers with the liner in this area, using red, white and lavender. Move over to the left again, and create the look of grass and flowers here, too. Dab for texture and pull grassy looks. Create an entire flower bed in the lower right. The sunlight is really strong, so use a lot of white to make it look bright.

Finish by enhancing the sunlight on the lawn with drybrushing, adding bright greens with a lot of yellow and white mixed in.

GARDEN WALKWAY
9" × 12" (23cm × 30cm)

Rocky Lake Scene

This project will give you practice with skies, bushes and trees, rocks and water. Follow along to create this pretty lake scene!

MATERIALS LIST

PAINTS
Alizarin Crimson, Burnt Umber, Cadmium Red Light, Cadmium Yellow Medium, Dioxazine Purple, Ivory Black, Prussian Blue and Titanium White

BRUSHES
½-inch (13mm) flat, 1-inch (25mm) flat, no. 2 flat bristle, no. 2 liner, no. 2 round bristle, no. 2 round sable or synthetic

CANVAS OR CANVAS PAPER
12" × 16" (30cm × 41cm)

OTHER
Mechanical pencil, small piece of cellulose kitchen sponge (optional)

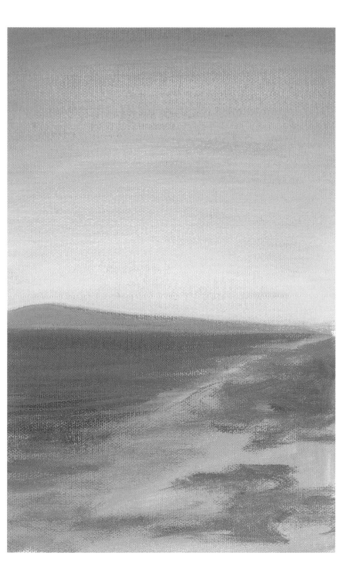

1 Basecoat

The Sky

Draw in the horizon line a little bit below center. Paint in the graduated sky with a 1-inch (25mm) flat. Mix a sky blue with white and a touch of Prussian Blue. Fill in the entire sky with this. Add a touch of Dioxazine Purple to the mixture and blend that into the top of the sky. Add white to the bottom and blend for a light look along the horizon.

The Mountain and the Water

Use the violet sky color to fill in the water with a 1-inch (25mm) flat. Mix a mauve by adding some Alizarin Crimson to white and adding a small touch of Dioxazine Purple to that. Apply this to the mountain range with a no. 2 round sable or synthetic. Switch to a no. 2 flat bristle and apply this color to the water on top of the bluish color you painted at first. Use horizontal streaky strokes to represent the water's surface.

The Ground

Create a sand color by mixing some Cadmium Yellow Medium with white and adding a small amount of Burnt Umber to it. Apply this to the entire ground area with the ½-inch (13mm) flat. Scrub some Burnt Umber into this when it's dry to represent shadows and where the water and the ground meet.

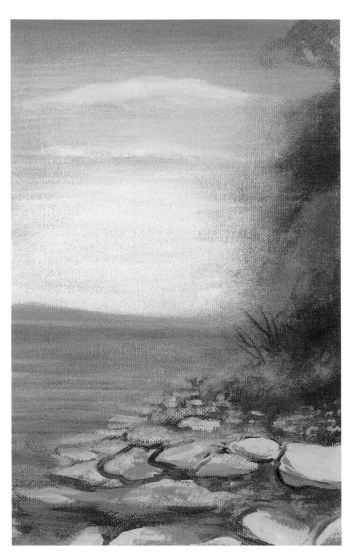

2 The Awkward Stage

The Sky

Cloud shapes offset the heaviness of the bushes and trees on the right. With Titanium White and a 1-inch (25mm) flat, add some clouds. Add some darkness to their underbellies with lavender (Titanium White and a touch of Dioxazine Purple). Add a tiny amount of this lavender to the white, and use horizontal streaks down towards the horizon line to give the sky a pastel tint.

The Water

Drybrush streaks of the pale lavender into the water as well. Use a little white as streaks, too.

The Bushes

Using the no. 2 round bristle, mix a deep brown with Burnt Umber and a touch of Ivory Black. Scrub it in with a circular motion for the darker bushes. For the light ones, add a small amount of Titanium White and a touch of Alizarin Crimson to the paint. Pull little limbs out with a liner and diluted Burnt Umber with a touch of Alizarin Crimson. Mix a green by adding a small amount of Cadmium Yellow Medium to some of the sky color. Scrub this in with the no. 2 round bristle directly below the limbs.

The Rocks

Mix the light sand color, and apply random round shapes that look like rocks into the foreground. With a liner and some diluted black, create the shadows below them with half circles. On the larger rocks, add a hint of red by adding Cadmium Red Light to the sand color. Apply this with a no. 2 round sable or synthetic. Scrub some Ivory Black into the sand to deepen the shadows with a loose dry-brush approach. Take some of the violet-blue used for the sky and scrub it into the foreground as well.

3 Finish

Finishing this is about revisiting each area and adding more light layers of color.

The Sky

Soften the clouds by drybrushing layers of light pink (Titanium White and Alizarin Crimson) and pure Titanium White in horizontal strokes.

The Mountain

Soften the color by drybrushing some of the pink color over it. Create a light pink edge where it meets the water by painting in the pink with a no. 2 round.

The Water

Drybrush streaks across the water horizontally using pinks, lavenders and light blues to make it sparkly.

The Bushes

Dab and drybrush to build up the foliage. Use circular strokes to scrub in the colors to make clumps of foliage. Start with Burnt Umber and Ivory Black for the shadows. Mix various shades of green using Cadmium Yellow Medium mixed with Prussian Blue or Cadmium Yellow Medium mixed with Ivory Black for olive green. You can use a piece of kitchen sponge, too, if you like. For the lighter colors, dab some of the sand colors into them. You can see the yellowish and reddish hues in the bush in the middle. Use light yellows for the light highlights on the bush in the front. Add some small limbs and branches within and throughout the bushes. Most of these have a subtle reddish color, like the rocks. Add them going in and out of the bushes with the liner and paint that has been thinned down to an inklike consistency.

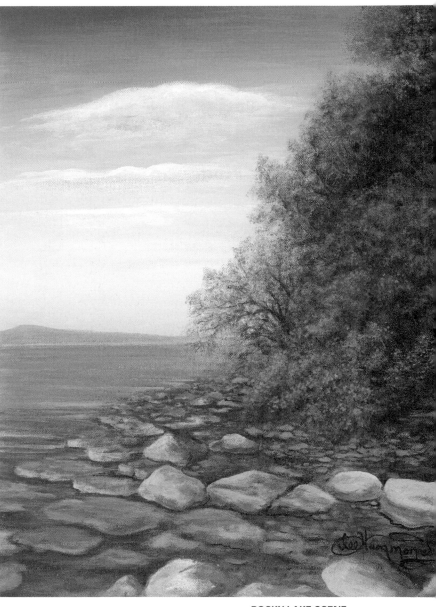

ROCKY LAKE SCENE
16" × 12" (41cm × 30cm)

The Rocks

Add a lot more detail with the sand color and the no. 2 round sable or synthetic until it looks extremely rocky throughout the foreground. Add a small shadow of dark brown and black under each rock for dimension. Add the subtle red tones to some of them, especially the ones on the left side of the trees. Each rock should look a bit different, so loosen up.

Go quickly, just dabbing them in without a lot of control. Drybrush streaks of a blue-gray (Titanium White with a touch of Ivory Black and Prussian Blue) lightly with a dry-brush application over the front rocks, enhancing some of the rocks to give the illusion of water coming in over them.

Rocky Stream

I love the feeling of depth created in this piece. It is due to the extreme contrasts of tones and colors, and how the horizon line quietly fades away into the background. This painting incorporates all of the things we have previously discussed, so you should have fun with it. To start the painting block in all of the shapes and colors in what looks like a color map.

MATERIALS LIST

PAINTS
Burnt Umber, Cadmium Red Light, Cadmium Yellow Medium, Ivory Black, Prussian Blue and Titanium White

BRUSHES
No. 2 liner, no. 2 flat bristle, no. 2 round bristle, no. 2 round sable or synthetic

CANVAS OR CANVAS PAPER
9" × 12" (23cm × 30cm)

OTHER
Mechanical pencil, small piece of cellulose kitchen sponge

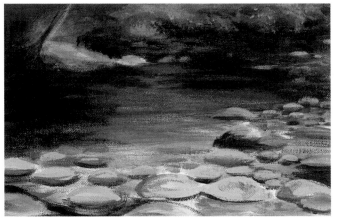

1 Basecoat

Sketch in the horizon line above center.

The Background

Apply green tones to the upper part of the painting with a mixture of Cadmium Yellow Medium and a touch of Prussian Blue, a no. 2 flat bristle and a circular scrubbing motion. Add a bit more yellow to the mixture and add the lighter green to the background for the light and dark bushes. Place this yellow-green into the water directly below the lighter bush. Scrub in black directly below the bushes for a shoreline. Take it clear across to the left side, leaving open the light areas that will become rock formations later.

The Water

Loosely block in the rocks in a variety of shapes and sizes with light tan (a little Burnt Umber and white) and a no. 2 round sable or synthetic. (Draw them first if needed.) Add light blue (white and Prussian Blue) to the rocks, too. Scrub a touch of black under some of the rocks. Use light tan and the no. 2 round sable or synthetic for the tree trunk leaning toward the water.

2 The Awkward Stage

The Water

Streak horizontal strokes of black into the water. Add more greens into the water, using the same colors as the foliage. Streak it along with the black for a reflective look. Drybrush a little Burnt Umber into the shoreline. Add Burnt Umber to the left side of the tree trunk, too.

The Rocks

Add a red (Titanium White with a touch of Cadmium Red Light and Cadmium Yellow Medium) to enhance the rocks. Loosely dot in more rocks to the upper right water area with the no. 2 round sable or synthetic and the same blue and tan you used before. Drybrush Burnt Umber underneath these. With black and the no. 2 round, outline under the edges of the larger rocks in the foreground.

The Foliage

Using the green tones from Step 1, dab foliage hanging over the water with a no. 2 round bristle.

3 Finish

The Background Foliage

The foliage in the background is highly affected by the light sneaking through the trees above. It is created with dabbing and the no. 2 round bristle. You could also use a piece of sponge. Alternate greens, ranging from deep with a lot of black mixed in to bright made with lots of yellow. Dab lightly with a minimum amount of paint to keep the texture subtle and airy. Look for the shadows and create the shapes that they create. The light is bouncing off the tree bark on the right side of the small tree leaning over the water and the ground next to it, so drybrush this texture with the no. 2 round bristle using a very light olive color mixed with Cadmium Yellow Medium, Ivory Black and Titanium White. Paint the small thin limb in front of the small tree with a thin, tapered line with thinned Ivory Black and the no. 2 liner. Add a small highlight down the top of it with Titanium White. Add all the small limbs you see in the painting using the liner. Look carefully, some of them are vague and difficult to see. Some are black, and some are white.

The Rocks

Apply the five elements of shading to the rocks (page 32). The ones that are larger and closer have more information. The smaller ones are vague. Use the same colors as before. Go one rock at a time and replicate what you see. Use the no. 2 round sable or synthetic for details. Drybrush in any color that is reflecting off the tops of the rocks with the no. 2 round bristle.

The Water

Use a no. 2 flat bristle to apply the horizontal streaks of color. Study my example to see the colors. Mix as you go. Your colors don't have to look just like mine. Look carefully under each rock and you will see a reflection of its color below it.

ROCKY STREAM IN BRITISH COLUMBIA
9" × 12" (23cm × 30cm)

New England Reflections

A friend of mine brought this photo into the studio wishing to draw it. I immediately fell in love with its wonderful colors and reflections. I knew I had to include it in this book. It has all of the elements that make a wonderful piece of art.

MATERIALS LIST

PAINTS
Cadmium Red Light, Cadmium Yellow Medium, Dioxazine Purple, Ivory Black, Prussian Blue and Titanium White

BRUSHES
1-inch (25mm) flat, no. 2 flat bristle, no. 2 liner, no. 2 round sable or synthetic

CANVAS OR CANVAS PAPER
9" × 12" (23cm × 30cm)

OTHER
Mechanical pencil

1 Basecoat

The Sky

Draw in the horizon line way above the center point to leave plenty of room for the water reflections. Use a light blue (white with a touch of Prussian Blue) to fill in the sky using a 1-inch (25mm) flat. It can be streaky at this point. Still using the 1-inch (25mm) flat, deepen the sky blue with more Prussian Blue and base in the entire water area with this color. Allow it to dry.

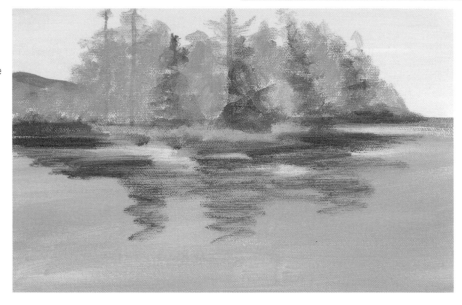

The Trees

Place the trees with rough representations. Refer to pages 58–59. With thinned-down black and the no. 2 liner, paint the vertical lines for tree trunks. Switch to the no. 2 round sable or synthetic and paint a black line across the horizon line to separate the sky from the water. Switch to the no. 2 round bristle and scrub in the black shapes within the group of trees. Create a golden color mixing Cadmium Yellow Medium with some Cadmium Red Light. Scrub in this for the gold trees. Apply this to the shoreline below the trees, too. Mix a green with Cadmium Yellow Medium and a touch of Prussian Blue to scrub in the green trees.

The Small Mountain

Mix some Dioxazine Purple into the sky color for a violet, and apply this with a no. 2 round sable or synthetic brush onto the small mountain range on the far left. Return to the water, and reflect the shapes of the trees loosely below them with Prussian Blue, horizontal streaks and a no. 2 flat bristle.

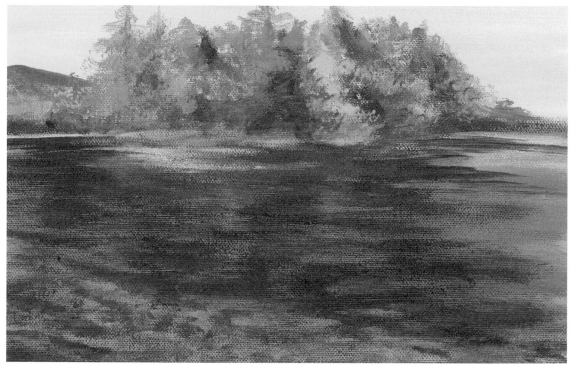

2 The Awkward Stage

The Trees

Build up the colors of the trees by dabbing with the no. 2 round bristle with orange (Cadmium Red Light and Cadmium Yellow Medium) and the same green as previously used. Add pure Cadmium Yellow Medium to the green mixture for the bright yellow tree right of center. Add a touch of Ivory Black to the yellow for an olive green, and dab that into the trees as well.

The Water

Reflect all the colors you just added into the trees into the water using the no. 2 flat bristle and horizontal strokes. Add more Prussian Blue horizontal streaks to deepen the overall color of the water. Go down to the bottom of the water and apply dots that represent rocks in the water using the same golden colors used for the trees and a no. 2 round bristle. There is a slight violet hue reflecting in the water on the right side. Use the color you used to apply the small mountain with a little Titanium White added. Apply this to the water area using the same horizontal strokes.

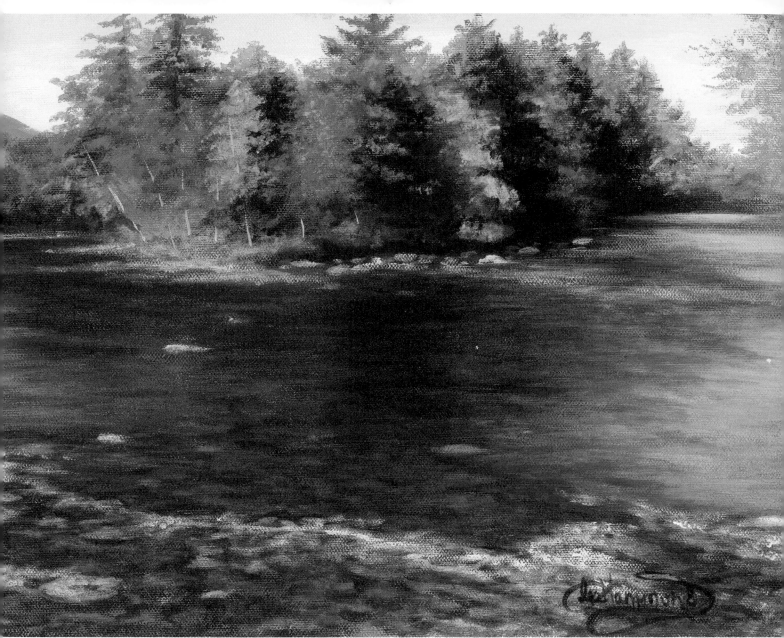

3 Finish

The final stages of a painting are always hard to depict in a book. It is impossible to show every step, so it is up to you to observe and study the finished piece, leaning on the information already presented, and hopefully, the practice work you have done so far. Here are a few of the things I did to complete this painting. Keep in mind that it was done in many layers.

The Sky

I decided at the last minute to add a few more white clouds to the sky using the no. 2 round sable.

The Trees

Continue dabbing to build the colors of the trees. Add a few tiny white limbs with watered-down Titanium White and a no. 2 liner. Add the light-colored trees coming in from the right side with light shades of orange and olive green.

The Water

Finish the water with continuous layers of color and the horizontal strokes. Watch how the colors of the trees are reflected directly below them in a mirror image. Add a few white rocks to the shoreline, giving them a slight reflection below, too. This stage takes a while, so do not rush. Build the colors of the rocks and the blue tones of the water in the rocky area at the bottom. Allow the colors to merge together so the water looks like it is over the rocks with light layering of color and drybrushing. With the no. 2 flat bristle, use Titanium White to drybrush waves and the water ripples.

REFLECTIONS IN NEW ENGLAND
9" × 12" (23cm × 30cm)

Brook in the Woods

This painting has many of the same elements as the previous project. However, this water scene is set in the woods, not out in the open, so it is much deeper in color.

MATERIALS LIST

PAINTS
Burnt Umber, Cadmium Red Light, Cadmium Yellow Medium, Dioxazine Purple, Ivory Black, Prussian Blue and Titanium White

BRUSHES
1-inch (25mm) flat, no. 2 flat bristle, no. 2 liner, no. 2 round sable or synthetic

CANVAS OR CANVAS PAPER
16" × 12" (41cm × 30cm)

OTHER
Mechanical pencil, small piece of cellulose kitchen sponge

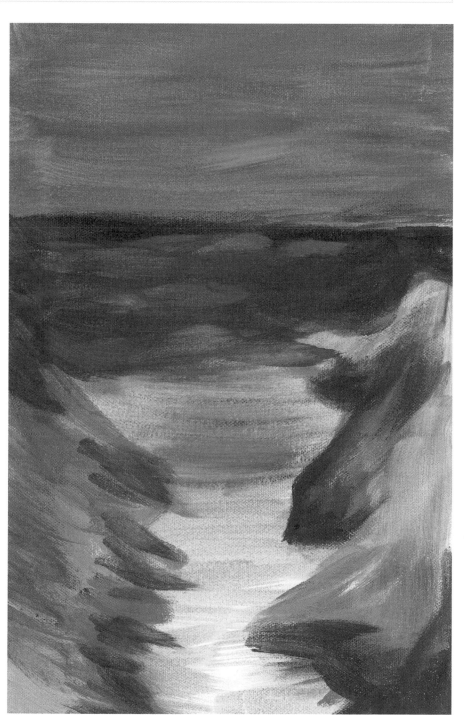

1 Basecoat

This painting starts with a lot of intense values. Rather than go from area to area, block in the entire painting with solid areas of color. Use a loose application of colors and a 1-inch (25mm) flat.

Draw the horizon line way up above center to allow room for the water in front. Make the top color by mixing Burnt Umber with a touch of Cadmium Red Light and a little Titanium White. Use a transparent application and base in the upper area down to the horizon line. Below the horizon line, use Burnt Umber and a bit of Ivory Black. Add a bit of Dioxazine Purple to the Burnt Umber mixture, and lighten it with some Titanium White. Use color for the ground on either side of the water. This does not have to be exact.

Base the water first with a gray created with Ivory Black, Titanium White and a touch of Dioxazine Purple. When that is dry, drybrush some bright white over it. In the middle apply a bit of lavender (white and a small amount of Dioxazine Purple).

2 The Awkward Stage
The Background Trees

There are a lot of fall colors in the foliage here, with dark undertones due to the shadows. With Burnt Umber deepened with a touch of Ivory Black, scrub in the dark values with a no. 2 flat bristle. Scrub in some Cadmium Red Light for the red foliage. Add some Cadmium Yellow Medium to the red for an orange, and scrub that in. Mix a green with Prussian Blue and Cadmium Yellow Medium, and scrub that in on either side. With a no. 2 round sable or synthetic, add some rocks in front of the trees with Titanium White. With diluted Ivory Black and the no. 2 liner, pull the limbs and trunks of the small trees.

The Shoreline

The shoreline is made up of rocky ledges. Remembering the information from chapter 5, loosely apply the lights and darks on the right side with the no. 2 flat bristle. The dark areas are the Burnt Umber/Ivory Black mixture. Add some Titanium White to it for the lighter brown colors. Add Titanium White to the top surfaces of the rocks, letting some of the lavender come through. Go to the left and streak in some of the lighter browns. This side is not as rocky and has a smoother surface as it goes towards the waterline.

The Water

Reflect some of the colors of the foliage into the water directly below using a horizontal stroke and the no. 2 flat bristle. Move down and streak some light blue (Prussian Blue and white) into the water as well. Make a light lavender with Dioxazine Purple and white, and streak it in. Add Titanium White to the water closest to the bottom.

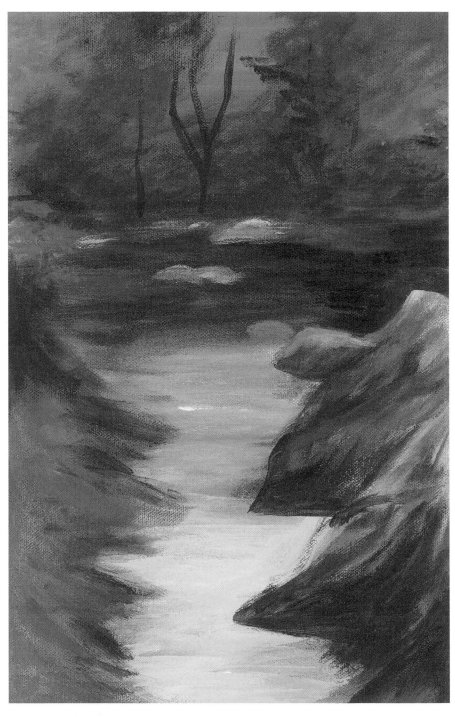

3 Finish

The Background Foliage

Add more small limbs and branches with the liner and diluted Ivory Black. Finish the foliage with dabbing and all the colors you used before. Allow the patterns to vary from large masses to the look of tiny stippling. Use a variety of brushes and a piece of sponge to get this look. The trees in the very back are duller in color and are heavily scrubbed to make them seem vaguer. Complete the water before the greenery on the left side. It overlaps the water and must be done later. It is done just like the background trees, with dabbing and stippling.

The Water

The water in the final painting looks much smoother and reflective. Notice how the horizontal strokes have come together and filled in a bit. Add a few white streaks into the water to reflect the rocks. Add a lot more Titanium White with a no. 2 round sable or synthetic and a zigzag stroke to give it the feeling of rushing down.

The Shoreline

Continue building the texture of the rocky ledge, adding highlights as you go. Add more brown tones to the shore on the left, streaking it down towards the water. The scrubbing technique with the no. 2 flat bristle will give the look of dirt and rocks.

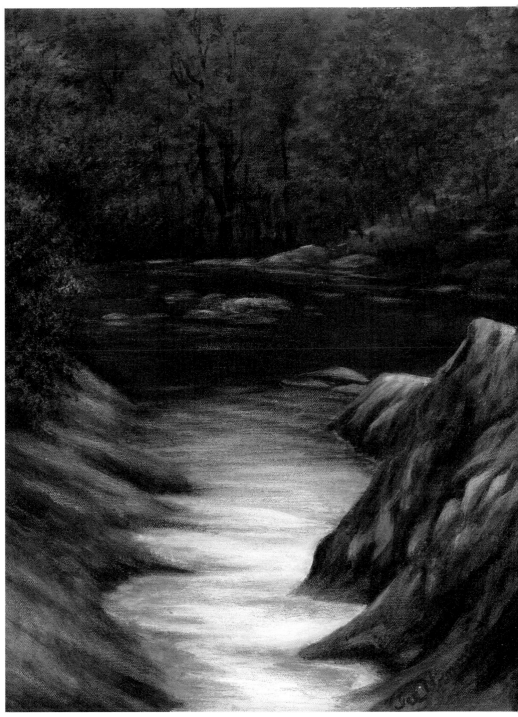

A BROOK IN THE WOODS
16" × 12" (41cm × 30cm)

Lavender Waves

Sometimes it is nice to simplify the composition and eliminate a lot of the business that we have learned to master so far. While trees and flowers are great, wide open spaces and the serenity of water are, too. This little beach scene is still fun to paint.

MATERIALS LIST

PAINTS
Alizarin Crimson, Burnt Umber, Dioxazine Purple, Ivory Black, Prussian Blue and Titanium White

BRUSHES
1-inch (25mm) flat, no. 2 flat bristle, no. 2 round sable or synthetic

CANVAS OR CANVAS PAPER
9" × 12" (23cm × 30cm)

OTHER
Mechanical pencil

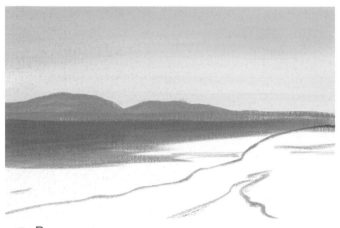

1 Basecoat

Draw a horizon line a little bit above the center.

The Sky

Mix a pale blue-violet by adding a small amount of Prussian Blue and Dioxazine Purple to Titanium White, and apply it to the sky with horizontal sweeping strokes and the 1-inch (25mm) flat. At the midway point, add more Titanium White. As you near the horizon line, add some Alizarin Crimson for a pale pink.

The Beach

Create a light brown by mixing Burnt Umber with Titanium White, and add a touch of Dioxazine Purple. Using the 1-inch (25mm) flat, apply this directly below the horizon line and take it across the canvas, allowing it to become thinner on the right.

The Mountains

Mix Titanium White, a touch of Alizarin Crimson and a small touch of Prussian Blue. Apply it to the small mountain range with a no. 2 round sable or synthetic. Add a little more Prussian Blue as it meets the brown at the horizon line. Place a little of this below the brown area on the beach. With the round and this color, sketch in the lines that represent the water movement.

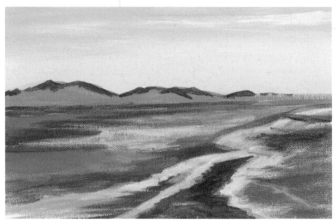

2 The Awkward Stage

The Sky

With the no. 2 round sable or synthetic, streak in some white and pink clouds. This is an area where you can do whatever you like. Just keep them soft and allow them to contrast against the darker color underneath.

The Mountains

Add some Ivory Black to the tops with the no. 2 round brush. Streak some black along the bottom of the mountains, too.

The Water

Use the no. 2 round sable or synthetic. Apply the same blue you mixed for the sky to the left side of the beach area. Mix a purple with the Dioxazine Purple and white, and apply it below the blue and in the dark area of the water. With Titanium White, add the froth of the waves, following the curvy patterns that they produce. Add some of the pink from the sky into the beach in the center of the painting. Remember that colors always reflect, especially on wet surfaces.

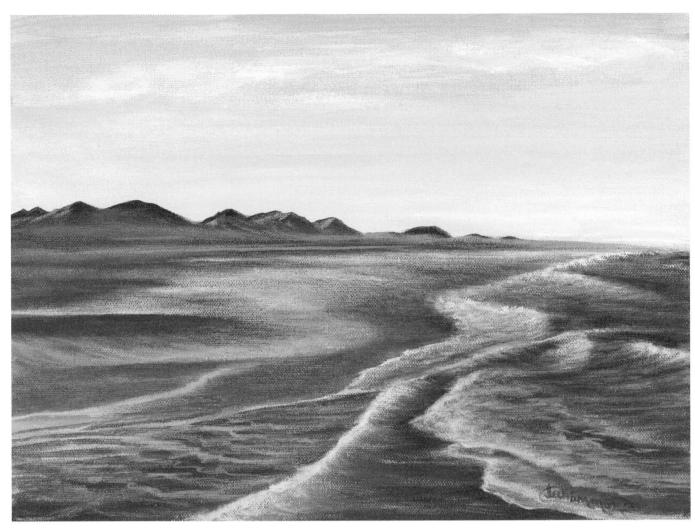

3 Finish

The painting is completed with layers of drybrushing and pastel colors of pink, blue and lavender. Finishing the painting requires a lot of drybrushing to soften and refine all of the colors.

The Sky

Add more streaks of pastel pink and white using a no. 2 round sable or synthetic.

The Mountains

Detail the mountains by creating the look of light reflecting off of them. Apply a warm, light brown (Burnt Umber, Titanium White and a touch of Alizarin Crimson) with the no. 2 round sable or synthetic. You can see the light on the left side of the peaks. Streak the warm, light brown across the horizon line on the right side for the look of sunlight. Apply violet (Titanium White, Dioxazine Purple and a touch of black) to the base of the mountains and let it streak upwards. Pull more Ivory Black down into this violet, allowing the colors to blend.

The Beach

With a no. 2 flat bristle, drybrush Titanium White across the top of the beach colors with horizontal strokes to soften. Add some pink and light blue as well (the same colors you used in the sky). Keep the paint very dry; you do not want it to cover up the colors completely. Add some of the purple on top.

The Water

The water and waves are also created with drybrushing. Look at how the patterns of the water are created with more horizontal strokes. Use the no. 2 flat bristle and streak the colors out and away from the white edges of the waves. With back-and-forth strokes and drybrushing, streak the water until it looks like mine. Alternate all the colors you used in the sky and the beach. Add Titanium White to the edges of the waves.

LAVENDER WAVES
9" × 12" (23cm × 30cm)

Lake Scene

I love the colors in this little lake scene with its beautiful warm glow. The combination of both warm and cool colors gives it a dramatic look.

MATERIALS LIST

PAINTS
Alizarin Crimson, Burnt Umber, Cadmium Red Light, Dioxazine Purple, Ivory Black, Prussian Blue and Titanium White

BRUSHES
1-inch (25mm) flat, no. 2 round sable or synthetic

CANVAS OR CANVAS PAPER
9" × 12" (23cm × 30cm)

1 Basecoat

Add a small amount of Dioxazine Purple to some Titanium White, and add a touch of Alizarin Crimson. Apply that color to the top of the canvas with horizontal sweeping strokes using the 1-inch (25mm) flat. Move down and add more white and a touch of Cadmium Red Light to warm the color. Continue with this all the way to the bottom. With the no. 2 round sable or synthetic and some diluted Ivory Black, paint in the horizon line above center. This places all of the attention on the body of water.

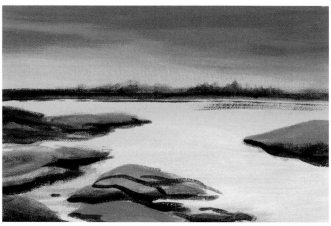

2 The Awkward Stage

The Sky

Using the 1-inch (25mm) flat, deepen the color of the sky using the color from the previous step and adding a bit more Dioxazine Purple to it. Allow it to streak to start the look of clouds. Add some Titanium White to the lighter sky color, and add it along the horizon line. Switch to the no. 2 round sable or synthetic again and add Ivory Black to the horizon line. Do some scrubbing to start the look of a tree row.

The Rocks

Mix two colors for the rocks: brown, made with the sky color and a bit of Burnt Umber added; and blue-gray, made by adding a tiny bit of Prussian Blue to Titanium White and adding a touch of Ivory black to that. Using the no. 2 round sable or synthetic, create the rocks using my example as a guide. They do not have to be exactly like mine. When you are done painting in the color, create some dark shadows underneath them with Ivory Black and the no. 2 round.

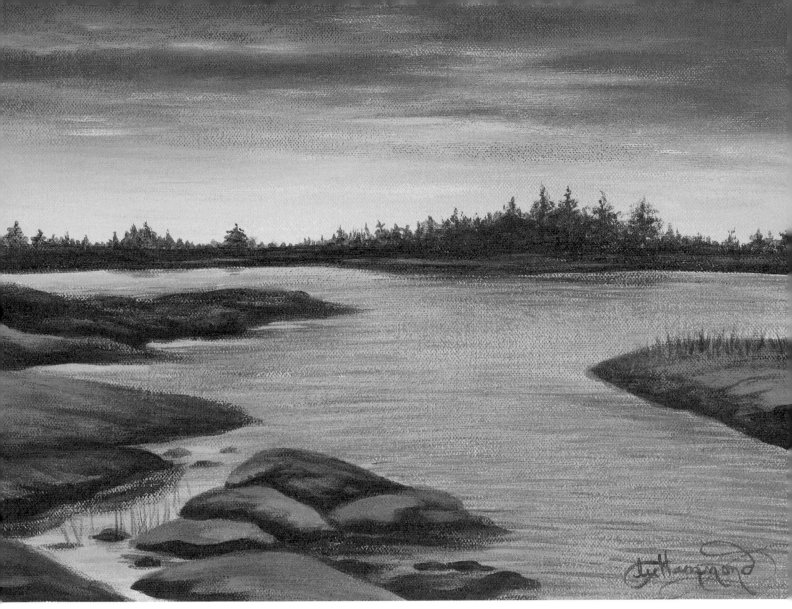

3 Finish

The Sky

Continue streaking colors in to give the illusion of cloud layers. Use the no. 2 round sable or synthetic and alternate light and dark colors until your sky resembles mine.

The Trees

With Ivory Black, add the tree row in silhouette. Start by applying the vertical lines for the trunks and building the shapes of the trees off of them.

The Rocks

Build up the colors of the rocks. Drybrush more Ivory Black to them to give them texture. Drybrush the colors of the sky onto the tops of the rocks as well. Add a few quick strokes of Ivory Black to the large rock on the right to give it the look of grass.

The Water

Drybrush repeated layers in horizontal strokes of all the colors you have used so far. It takes many, many layers. Create the dark reflections under the trees and rocks with black and the blue-gray color used for the rocks in Step 2.

LAKE SCENE
9" × 12" (23cm × 30cm)

Putting It All Together

This is where it can get really fun. The next few demonstrations will combine everything you've learned with the magic of light effects.

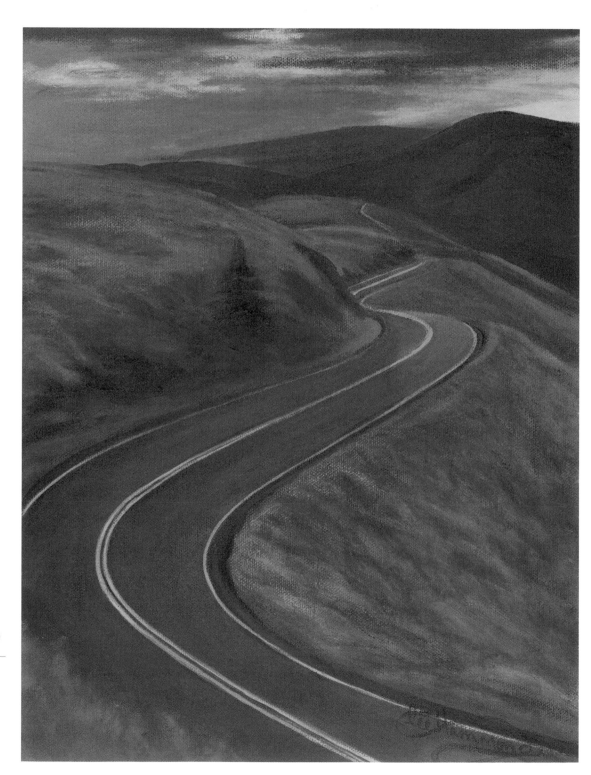

WINDING SUNSET HIGHWAY
12" × 9" (30cm × 23cm)

Colors Used: Alizarin Crimson, Burnt Umber, Cadmium Red Light, Cadmium Yellow Medium, Dioxazine Purple, Ivory Black, Prussian Blue and Titanium White

Winter Sun Glow

I love this piece for its rich colors and golden glow. I used both warm and cool colors to give it the wintry appearance. The warm yellow glow coming through the trees makes the violet colors of the shadows look even deeper and very cool in contrast. The horizon line of this piece is below center to allow the sky and background to be dominant.

MATERIALS LIST

PAINTS
Alizarin Crimson, Burnt Umber, Cadmium Red Light, Cadmium Yellow Medium, Dioxazine Purple, Ivory Black, Prussian Blue and Titanium White

BRUSHES
1-inch (25mm) flat, nos. 2 and 4 flats, no. 2 liner, no. 2 round sable or synthetic

CANVAS OR CANVAS PAPER
9" × 12" (23cm × 30cm)

1 Basecoat

This stage of the painting is the foundation for the entire piece. It is all done with blending and the 1-inch (25mm) flat.

The Sky

Start at the top and work down. Create the peach color by mixing a small amount of Cadmium Red Light with Titanium White. Apply it with sweeping horizontal strokes that go completely across the canvas from edge to edge. As you move down, add a small amount of Cadmium Yellow Medium to the mixture. Add pure Cadmium Yellow Medium along the horizon line and blend these together until it looks smooth and gradual.

The Foreground

Move to the horizon line and apply the same peach color you used for the sky. As you near the bottom of the canvas, add a small touch of Alizarin Crimson to the paint. Mix a violet by adding a small amount of Dioxazine Purple to Titanium White. Deepen that by adding a tiny amount of Prussian Blue. When the peach foundation is dry, apply the violet color below the horizon line. Add the small dark streak above it by mixing Alizarin Crimson into a small amount of the violet.

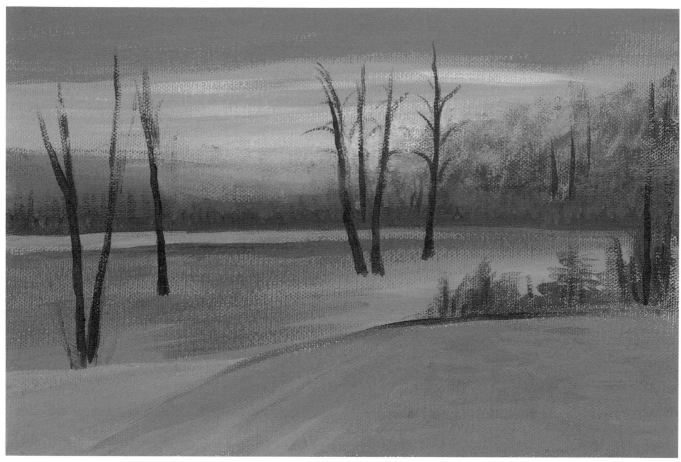

2 The Awkward Stage

The Sky

You'll be drybrushing at this point with the no. 4 flat. Apply a pale orange (Cadmium Red Light and Cadmium Yellow Medium) directly above the horizon line going from edge to edge. On the right, use a circular scrubbing motion to create the tree row. Add a small amount of Titanium White to some Cadmium Yellow Medium, and drybrush this into the sky to make it look streaky. Using the circular scrubbing motion, apply it to the tree row as well.

The Foreground

Add some highlights to the violet area by mixing a pink with Alizarin Crimson, Titanium White and a very small amount of Dioxazine Purple. Drybrush this over the violet allowing the texture to show.

Apply this lighter color under the horizon line on the left side. Increase the darker streak below that with the Alizarin Crimson/Dioxazine Purple mixture to make it look more like a shadow than just a streak. Add the shadows of the trees into the foreground on the right. They have a bluer appearance. Add a tiny amount of Prussian Blue to the violet mixture used for the middle ground. Drybrush in the shadows with this as shown.

The Trees

With the no. 2 flat, scrub in the smaller, darker tree row with Burnt Umber mixed with a small amount of Cadmium Yellow Medium. First use a horizontal stroke to create the horizon line, being sure that it is straight across. Then use quick vertical strokes upward to start the illusion of trees. Move below the horizon line to the foreground. With the same Burnt Umber mixture and the same technique, add the foundation for the small trees where the peach and the violet colors meet. With your no. 2 liner, add the tree trunks. Add a small amount of Ivory Black to the Burnt Umber to deepen it, especially at the bottoms of the trunks. The trees in the middle are in the direct sunlight, so add Cadmium Red Light to the tops of them.

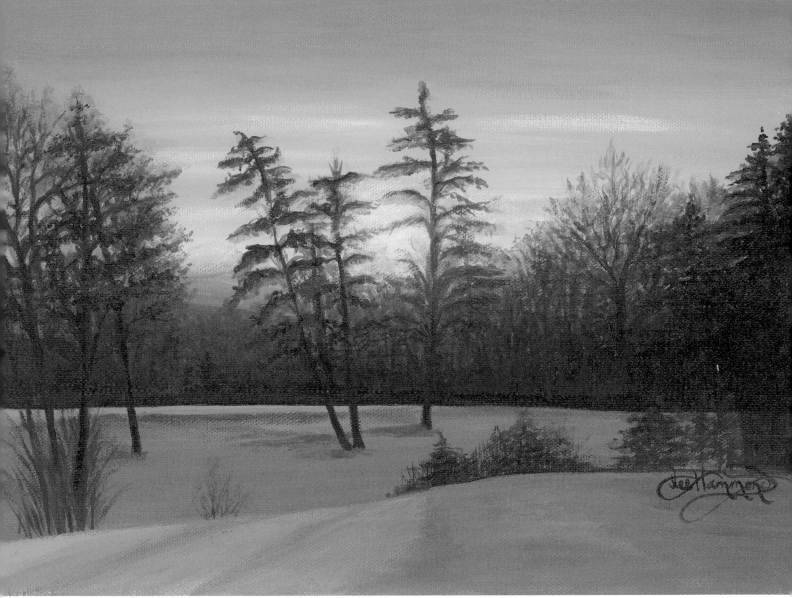

3 Finish

The Trees

Continue developing the trees with the Burnt Umber/Ivory Black mixture. Add some more trees to the horizon line using the no. 2 flat and dabbing and scrubbing. Add the limbs and branches of the trees in the middle ground and the larger one in the background using the no. 2 liner. Add some Cadmium Red Light and Cadmium Yellow Medium to the outside edges to create the sunlit glow.

The Small Details

Using the same brush, add the grassy areas around the trees on the left with Burnt Umber, including the small shadows to the left of the trees. If your painting doesn't have the same intensity, you can increase the colors as you go by drybrushing on top. Add some more Cadmium Yellow Medium into the sky and a little Titanium White in the middle to give the illusion of sun. You could also increase the pink tones in front for more warmth. Again, the wonderful trait of acrylic is the ability to adjust color easily by drybrushing. Alterations are easy.

Snowy Road

This painting requires only three colors. The lack of color in this piece gives the painting a cold appearance, fitting for the season it represents. And you'll practice four distinct painting techniques: blending, pulling, drybrushing and dabbing.

MATERIALS LIST

PAINTS
Ivory Black, Prussian Blue and Titanium White

BRUSHES
1-inch (25mm) flat, no. 2 flat, no. 2 liner, no. 4 round

CANVAS OR CANVAS PAPER
9" × 12" (23cm × 30cm)

1 Basecoat

The Sky

Begin with the high horizon line to put focus on the foreground. Starting with the top and your 1-inch (25mm) flat, apply a medium blue (Titanium White and a tiny bit of Prussian Blue) horizontally with long sweeping back-and-forth strokes that go completely across the canvas from edge to edge. As you move down, add more white to gradually lighten as you near the horizon line.

The Road

With the same color and brush, roughly apply the blue at the bottom and down the center of the road. Curve with the shape of the road. If the strokes are too straight, the hill will look too steep.

The Trees

Switch to the no. 2 flat for the tree and bush shapes using a scrubbing, back-and-forth motion and a little light gray (add a small amount of Ivory Black to Titanium White). Start with the horizon line. These trees appear lighter and smaller since they are farther away. Vary their sizes for depth. Move to the trees and bushes on the sides. Apply some of the light gray to the ground before you start. Deepen the color of gray since these trees are closer. Add a small amount of the medium blue mixed for the sky in places so everything doesn't all look the same. Apply a darker color to the bushes on the right first, with a lighter color scrubbed on top. This begins the layering process for thickness and volume. Use the no. 4 round for the tall trees on the left and pull upward.

The Shadows

With the same darker shade of gray, apply the shadows created by the trees over the blue tones previously applied at the bottom.

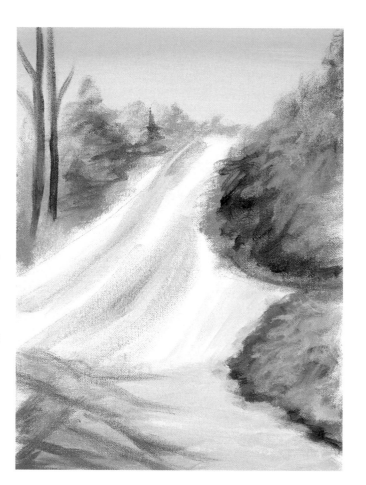

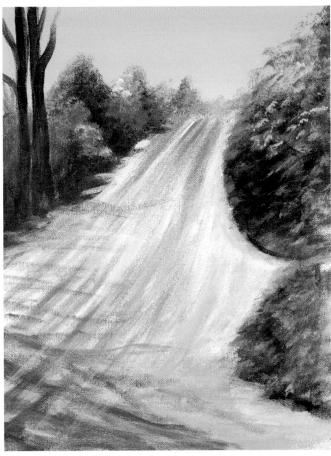

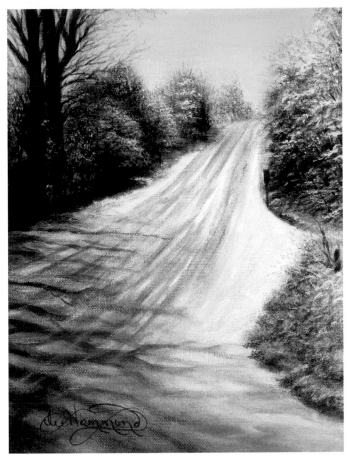

2 The Awkward Stage

The Trees

Add more Ivory Black to the trees to make them fuller and more dimensional. Scrub in the darker tones using the no. 2 flat and a circular motion. Dab lighter colors of blue and gray on top of the trees.

The Shadows

Deepen the shadows and tracks on the road with dark gray and the dry-brush technique. If you apply too dark, just drybrush back over it with Titanium White.

Choosing Reference Photos

When picking photos to work from, or taking pictures with the intent of turning them into art, I look for interesting lighting and shadows to make the piece more dynamic and interesting. They always give the painting more realism and depth.

3 Finish

Take as much time as needed to build up realism.

The Trees

With the no. 2 liner and diluted Ivory Black that flows from your brush like ink, pull more branches and limbs on the large trees on the left. Make them very small and delicate as they get farther away from the tree.

The Snow

With white and the no. 2 flat, dab the look of snow on the bushes and the trees with a small amount of paint and a light touch, building it up gradually in layers.

The Limbs

Use the no. 2 liner and the diluted Ivory Black to place broken lines within the bushes so they look like small twigs going in and out of the snow and foliage. The ones in the back appear thinner and lighter.

A SNOWY WINTER ROAD IN KANSAS
12" × 9" (30cm × 23cm)
From a photo by Dinah Medina

135

Country Afternoon

We have seen how important the use of color and lighting is to creating beautiful art. Nature is the great provider of color and light, and this painting captures it wonderfully. The finished painting may seem a bit daunting at first, but it really is no harder than the previous demonstrations. It takes everything we have learned so far and wraps it up in one big project. This is another painting that would look great on a large scale. Make it as large as you like. Just adjust the sizes of your brushes accordingly and mix a lot more paint for each step.

MATERIALS LIST

PAINTS
Alizarin Crimson, Burnt Umber, Cadmium Red Light, Cadmium Yellow Medium, Dioxazine Purple, Ivory Black, Prussian Blue and Titanium White

BRUSHES
1-inch (25mm) flat, no. 2 flat bristle, no. 2 round sable or synthetic, no. 2 liner, no. 2 round bristle

CANVAS OR CANVAS PAPER
12" × 16" (30cm × 41cm)

1 Basecoat

The Sky

Draw in the horizon line a little bit below center. Apply sky blue (Titanium White and a bit of Prussian Blue) with horizontal strokes and the 1-inch (25mm) flat to the top and upper right corner of the canvas. Move down to the horizon line and apply pure Cadmium Yellow Medium to the left side moving up to the halfway mark. Add a small amount of Alizarin Crimson to the yellow, and continue up using horizontal strokes, allowing the color to make streaks. Add a small amount of Titanium White and a touch of Dioxazine Purple to the mix, and carry it up using the horizontal strokes until it meets and overlaps the sky blue. With the Alizarin Crimson mixture, switch to a no. 2 round sable or synthetic and paint in the line across the horizon line.

The Foreground

Mix a light blue-violet with Titanium White, a touch of Prussian Blue and a touch of Dioxazine Purple. With the 1-inch (25mm) flat, apply this from the horizon line down to the bottom of the canvas.

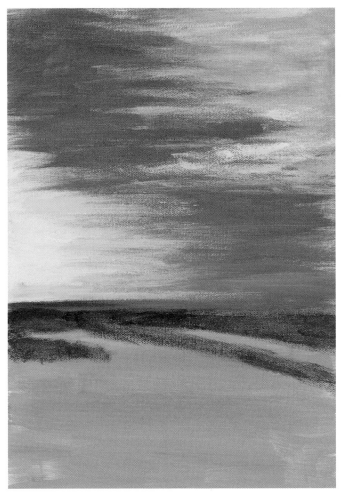

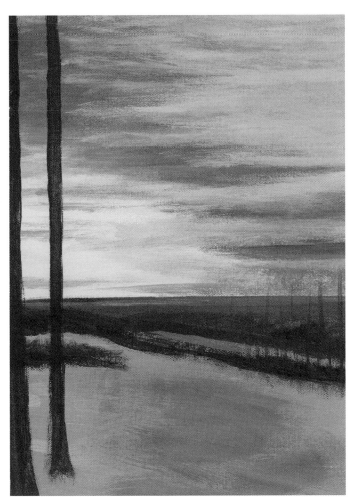

2 Basecoat, continued

Start the look of clouds, and create the dark tones in the background.

The Sky

Mix a light yellow by adding a small amount of Titanium White to Cadmium Yellow Medium. Use a no. 2 flat bristle to drybrush the light clouds in the upper right with horizontal strokes. Carry the strokes down into the reddish colors. Using the sky colors from Step 1, continue streaking the sky using the no. 2 flat bristle. Notice how the colors are blending together.

Remember that your sky can look different than mine. Skies are ever changing with no too alike. If you like more red or pink, put more in.

The Foreground

With Ivory Black, apply the darkness below the horizon line using the no. 2 flat bristle.

3 The Awkward Stage

The Sky

Continue with the previous colors and the no. 2 flat bristle, streaking to create the look of a sunset. Add more yellow tones to the horizon area. Continue working and reworking until it seems just right to your eye.

The Foreground

Switch to the no. 2 round sable or synthetic and the Alizarin Crimson/yellow mixture to define the horizon line and create the look of a background hill in the distance. Add a small amount of it below the tree row in the middle, too. Switch to the no. 2 flat bristle, and build up the look of trees in the right background area using the scrubbing technique with Ivory Black. Scrub some Burnt Umber into the tops of the tree masses. Using the same brush and Ivory Black, create the dark streaks in the foreground.

The Trees

Add a touch of Ivory Black to some Burnt Umber, and paint the larger tree trunks with the no. 2 round sable or synthetic. Switch to the no. 2 liner, and add the smaller trunks on the right.

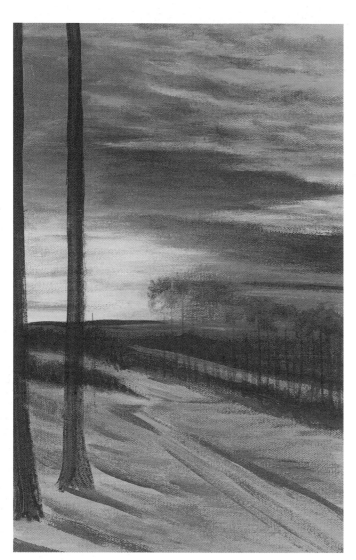

4 Deepen and Warm

Deepen the colors of the sky, and continue building the look of trees. Add the warm sky color to the foreground.

The Sky

Using the no. 2 flat bristle, continue adding colors with horizontal streaking strokes. Add more reds with Alizarin Crimson and a small amount of Titanium White and Cadmium Yellow Medium to deepen the sky to give more of a late-afternoon look. You can see how the sky-blue color is starting to get covered up now. Don't cover it completely. It must show through in areas. Move down to the sky on the right directly above the horizon line. Brighten this with some Cadmium Red Light.

The Small Trees

With thinned Ivory Black, scrub in the look of tree foliage with circular strokes and the no. 2 round bristle. Add a few more trunks with the liner.

The Foreground

Start developing the sunlit appearance on the snowy ground. The cool light blue-violet color already there will peek through the warmer colors on top. Reflect the reddish color from the sky down onto the ground using the no. 2 flat bristle along the right side of the shadow patterns. Notice how they are creating the look of a gentle slope and a sunlit path.

Remember!

Acrylic is the most forgiving medium you can use. If you are unhappy with any area, simply rework it. If areas of your painting get too dark, simply add some lighter colors. If too light, add some darker ones. You are in charge and you have the ability to make as many changes as necessary. Don't give up. You can do it!

5 Finish

This will be a process of building and layering colors with the dry-brush application. I find this stage much like drawing with a brush.

The Sky

Use the no. 2 flat bristle to drybrush more cloud layers. Use the Alizarin Crimson mixture from previous steps and the light yellow/white mixture to create the layered stratus clouds. Use white to add the sun in the middle. Streak the yellow/white mixture out from it to make it look soft and hazy, with the look of sunrays. Keep this subtle. Add more Cadmium Red Light glow behind the trees on the right.

The Trees

Add more trunks to the trees on the right with the liner. Continue to build up the tree foliage scrubbing with the no. 2 round bristle and a combination of Burnt Umber and Ivory Black. Scrub some Cadmium Red Light into them, too, to make it look like the sunglow is passing through them. For the shorter, small trees in the distance, scrub in some Burnt Umber with a bit of Cadmium Red Light to make them look fuller. Switch to the no. 2 liner, and use thinned paint to pull thin tapered lines for small limbs and branches coming from the large trees on the left. Deepen the color of the trunks with Ivory Black/Burnt Umber. Drybrush a small amount of pure Burnt Umber into the right side of the trunks to highlight.

The Foreground

This is the part that will take the most time, but it is the most important. It is all about drybrushing a combination of the warm and cool colors and making them work together to create the soft illumination of the snow.

Using scrubbing, horizontal strokes that keep consistent with the patterns of sunlight, the no. 2 flat bristle and the blue-violet from the foreground in Step 1 with a bit of Ivory Black added to make it grayer, create subtle shadows in the dark areas. Add a small amount of white to the blue-violet for the lighter shadow areas where they appear bluer.

Drybrush light warm colors of the sky next to and on top of the cool shadow colors to illuminate the light areas on the ground. It may take a while to get the same look as mine. When you have completed the foreground colors, add the small grasses and twigs with Ivory Black and the liner.

SNOWY COUNTRY AFTERNOON
16" × 12" (41cm × 30cm)

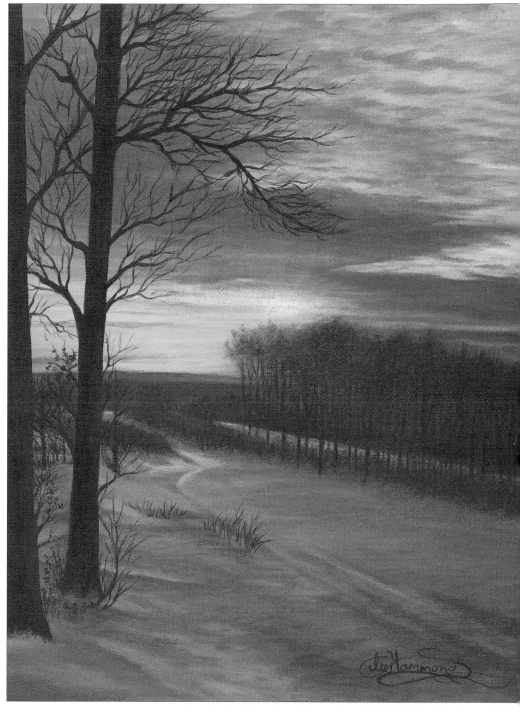

Conclusion

Well, we have reached the end of the rainbow together! I hope this book has inspired all of you. I am always disappointed when one of my books reaches its conclusion, for I feel as if I could go on forever. There never seem to be enough pages for me to fill. I still have a pile of landscape paintings yet to be completed!

As a teacher, I am continually trying to learn something new and different to pass along to my students. Hopefully within the pages of this book, I have passed something along to you. I learned a lot myself just by writing it! Students are my reason for being. I fully believe that it is my calling to be there for the aspiring artists, who continually strive to learn more and more about art and who are determined to become the artists they've always wanted to be.

I feel so fortunate to have this God-given ability, combined with the incredible opportunity that North Light Books gives me, to help you learn through my books. It is always my goal to make your learning process a little easier along the way. Hopefully I take away some of the frustration and allow you a bit more joy as you grow as an artist. I thank all of you so much for joining me on my artistic pursuit, and I truly appreciate your taking me along on yours. Here's to many more happy artistic years together! Your friend,

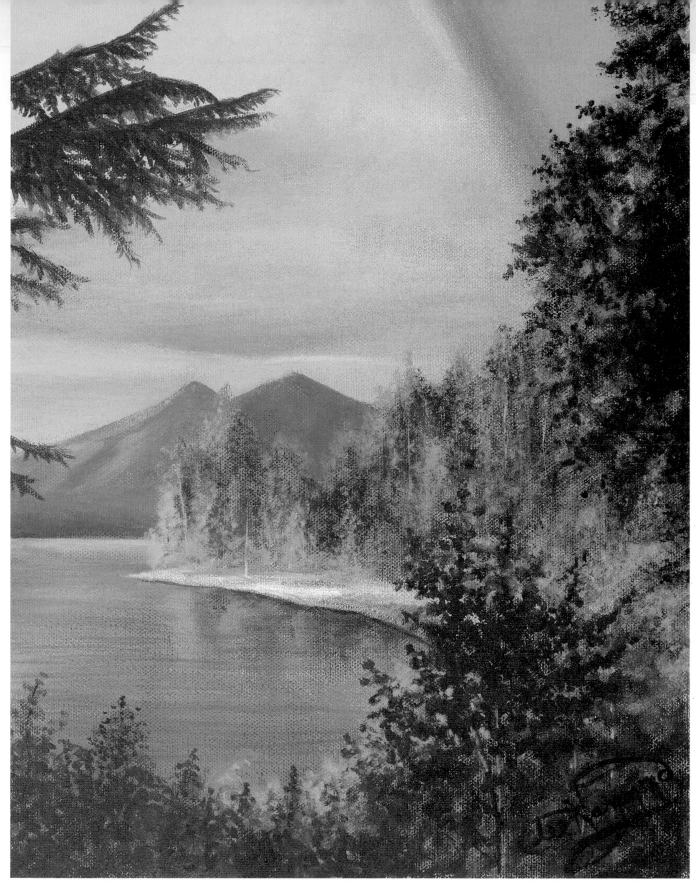

THE END OF THE RAINBOW
12" × 9" (30cm × 23cm)

Colors Used: Alizarin Crimson, Burnt Umber,
Cadmium Red Light, Cadmium Yellow Medium,
Dioxazine Purple, Ivory Black, Prussian Blue and
Titanium White

Index

Look For More Art Instruction
From Lee Hammond and North Light Books!

Painting Animals in Acrylic with Lee Hammond
Lee Hammond demonstrates how to create realistic Animals with acrylic paint. Follow along with Lee to learn the various techniques for applying paint, which colors and which brushes to use, and how to use them for realistic results.

ISBN-13: 978-1-60061-825-3
DVD, 79 minutes, #Z5359

Drawing Lifelike Portraits with Lee Hammond
Lee Hammond demonstrates how to achieve lifelike portraits through smooth blending and gradual tonal changes. She shows you how to create subtle gradation changes and shading of a sphere for more realism. You'll learn what tools to use and how to use them for fantastic results.

ISBN-13: 978-1-60061-813-0
DVD, 90 minutes, #Z5347

Paint People in Acrylic With Lee Hammond
With over 20 step-by-step projects, Lee Hammond walks you through painting realistic and detailed portraits.

ISBN-13: 978-1-58180-798-1
Paperback, 128 pages, #33476

These and other fine North Light books are available at your local art & craft retailer, bookstore or online supplier.

Visit www.artistsnetwork.com and get Jen's North Light Picks!
Get free step-by-step demonstrations along with reviews of the latest books, videos and downloads from Jennifer Lepore, Senior Editor at North Light Books.